RIDING THE
D O G

A LOOK BACK
AT AMERICA

also by Thomas E. Kennedy

Novels

A Passion in the Desert
Danish Fall
Greene's Summer
Bluett's Blue Hours
Kerrigan's Copenhagen, A Love Story
The Book of Angels
A Weather of the Eye
Crossing Borders

Story Collections

Cast Upon the Day
Drive Dive Dance & Fight
Unreal City

Essay Collections

The Literary Explorer
Realism & Other Illusions: Essays on the Craft of Fiction

Literary Criticism

American Short Story Award Series
Robert Coover: A Study of the Short Fiction
The American Short Story Today
Andre Dubus: A Study of the Short Fiction

Anthologies

New Danish Writing: Voices from the Blue Port & Beyond †
Writers on the Job *
The Secret Lives of Writers *
Poems & Sources †
Stories & Sources †
Small Gifts of Knowing: New Irish Writing
New Danish Fiction ‡

* with Walter Cummins
† anthology issues of *The Literary Review*
‡ anthology issue of *The Review of Contemporary Fiction*, with Frank Hugus

RIDING THE
D O G

A LOOK BACK
AT AMERICA

essays by

Thomas E. Kennedy

NEW AMERICAN PRESS

Fort Collins, Colorado

NEW AMERICAN PRESS

ISBN 978-0-9817802-1-4

Three of these essays appeared originally in *New Letters* magazine,
the fourth, in altered form, in *The Literary Explorer*. Five of the six
essays were nominated for Pushcart Prizes; three received honor-
able mention and one was reprinted in *New American Essays*. The
foreword by Robert Stewart appeared originally in altered form in
South Carolina Review. "Life in Another Language" was originally
published in a cross-brand issue of *The Literary Review* and *Frank:
International Journal of Writing & Art*, guest-edited by David Ap-
plefield (Fall 2003). "Bailing Out in Peoria" appears here in print
for the first time.

Illustration for "Riding the Dog" is detail of an oil painting by an
unknown artist and acquired by Mayo Mac Boggs of South Caro-
lina—prior to 2001 (reproduced with permission). Illustration for
"Land Where My Fathers Wrote" is detail of artwork from facade
of the Nuyorican Poets Café at 236 East 3rd Street, New York.
Photograph for "Bailing Out in Peoria" by Greg Boiarsky, Yellow
Dog Photography. Author photo by Alice Maud Guldbrandsen. All
other interior photography by Thomas E. Kennedy.

CONTENTS

For my American friends and family.

Also with deep thanks to
Robert Stewart, Walter Cummins, and Duff Brenna
for their invaluable advice, sustaining encouragement,
and friendship.

And always for Daniel and Isabel.

Foreword

WE NEED A GOOD TERM for the kind of writing you will encounter in this remarkable sestet of pieces by Thomas E. Kennedy. Back in 1989, my magazine, *New Letters*, began publishing Kennedy's short stories—starting with "What Does God Care About Your Dignity, Victor Travesti?" and proceeding to the O.Henry Prize winner "Landing Zone X-Ray" and beyond. Then, in 2003, he began sending us the kind of writing collected in this book, what most people would call *non*fiction—a term that equivocates, however, because it would define this writing by what it is not. The narrative skill of a great fiction writer drives the writing here, and also fact, recollection, journalistic fidelity. Let's not call them memoirs, either, because their purpose transcends the mere recalling of events. These are essays; they aspire to a conceptual complexity, while leaping over anything that resembles the dull, trapped, tapestries of academic prose. These essays embrace a tradition that includes George Orwell and Joan Didion; even today, anthologists can't decide if Orwell's "Shooting an Elephant" or his "Marrakech" should be called fictions or essays. I say essays.

As with Orwell, Dickens, Gellhorn, and many others, Thomas E. Kennedy has pushed the essay form to its brightest moments, in which fact can have its poetry, its narrative, its characters, its emotion, and its intellectual integrity. "To speak well is part of living well," the critic Gaston Bachelard

has written. This is Tom Kennedy's gift: language not as an instrument of explanation but as the primary experience, itself. The vitality of fiction translated to fact. Matthew Arnold noticed early versions of a similar style in journalism back in the 1880s, calling it vivid, highly personal, and, occasionally, featherbrained. Tom Kennedy, I am sure, would welcome all those terms.

How featherbrained can one be on a Greyhound, cross-country bus ride, to cozy up to folks who eye you with suspicion and with whom you have virtually no common background? Then, try to write about them with authenticity. The essay, as Kennedy writes it, stands apart from fiction and poetry by requiring his full participation in the experience—first-hand and faithful—promoting a different kind of author-reader pact. We read these essays expecting to learn less about how we might think than how we might live.

In "Riding the Dog," a nearly illiterate man asks the author, "What 'choo do?" and Kennedy thinks a moment: "I considered telling him I was on my way to read a story at a public college in Chicago where there has been a recent uproar over a Picasso sculpture on display there." The contrast illustrated here between the speaker and the man actually heightens the stature of the author's bus mate, and of all the other people on the bus who never would have time or energy to get into an uproar over a sculpture of a woman whose breast was larger than her head. Kennedy's trick—a great trick, delivered with no small bit of humor—is to reverse his

own relative privilege and to halo the sanctity of people around him who at first seem lost or even dim.

In "In the Dark," the author stops to help a woman, Chanel, and her three-year-old daughter, Kyla, who are huddled in a doorway, exhausted and thirsty. Of course the author's idea is to bring them to the lounge at the Plaza Hotel, to him "a haven of civilization." Of course, they are blocked by the doorman; and, of course, Chanel understands the situation perfectly, while the author can't quite, at that moment, comprehend the lesson he is being shown about rank and status here in America.

In some perfect way, each of these works—especially the exuberant and melancholy essay "The Bridge Back to Queens"—shows Thomas Kennedy coming home from his adopted Denmark, still carrying the intractable naïveté of his youth. His affection for and irrevocable connection to his home country carries a kind of furious need to get cozy all over again with the places and people for whom he holds such feeling. Here, "Land Where My Fathers Wrote" and, even more, the inclusive and bridge-building "Life in Another Language" take us all in, both geographically and spiritually. In "Bailing Out in Peoria," Kennedy's self-effacement in an essay about a cross-country trip—half by pedal, half by thumb—mirrors the journey of his literary life, a journey on guts, kindness, and humility. Kennedy is an expatriate in the end; and in the end, he recovers, and helps us recover, our ideal land.

Another great essayist, William H. Gass, has asked in his own writing, "What must a work do to pass the Test of Time?" Gass advises, in part, "Don't take the test at all." Essays such as Kennedy's are not so much ideas as events, in themselves, Gass would say, invested with value. So, I would reject the term *personal* essay, as well, in Kennedy's case. These essays will pass the test of time, I believe, because they ultimately are not personal at all, but spiritual.

Three of the six came in the mail to me at *New Letters* magazine one by one, each answering the question I, as editor, ask myself every day: How can I give meaning and importance to the work of this magazine? In each case, I embraced this writing. In each case, I saw the life of one man, sure, but also my own life, and the life of the essay, itself, which can hardly be contained.

ROBERT STEWART
editor, *New Letters*

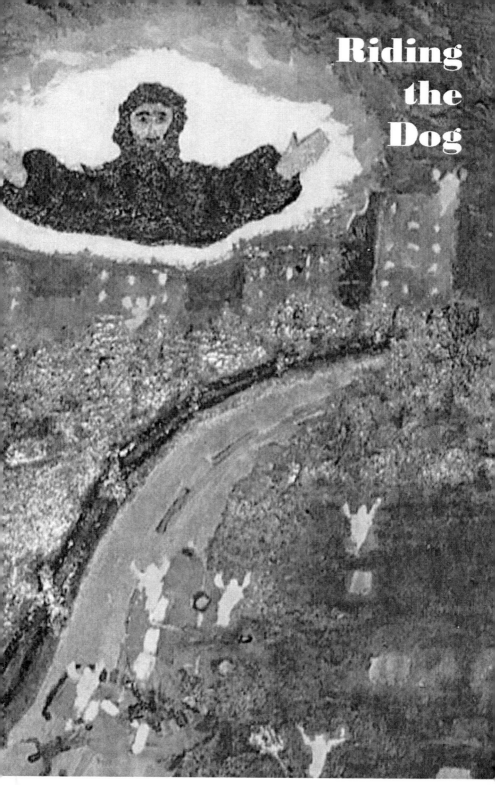

Riding the Dog

THE YOUNG MAN CARRIES HIS POSSESSIONS in a brown paper
bag and a shoebox. I notice him when I board the coach at
Greenville. His name is Marvin, and he wears a pale blue
shirt and baggy yellow pants, no jacket despite the nippy
January afternoon. He tells a friendly, brown-faced woman
in the seat across the aisle from him that he has been travel-
ing for over thirty hours, since Detroit, and that he is 23
years old and has been in prison since he was 16.

I wonder what he was in for. Drugs probably. Packed
away during the 90s when tough laws cleaned the streets of
rubbish so the increasingly wealthy folk felt free to go out
and spend their fortunes. Now the prisons, like most every-
one else, are going broke and slipping loose the nonviolents,
as an economy measure.

An hour south, at a brief stop outside Greenwood, the
clan of smokers gather around a redwood table and light up.
The friendly brown-faced woman from the bus sits on the
bench near where I stand. She tells me she's been on since
Detroit, too, and we chat about means of transport and
smoker facilities, the little smoky gas chamber I encountered
a while back on the Amtrak from New York to Chicago.

I refrain from telling details, about the grey-blonde red-
eyed man who emceed the room, asking everybody's business
in exchange for his. He had been on the train since Tampa,

bound for Chicago to confront Fred Myers over a contract dispute. "I ain't satisfy with what he pay me." His wife, twice his size, called him "Fat Boy," and one of the others said, "You look just like that guy on the Dr Pepper ad!" A large black woman puffed a Chesterfield and told a little white-haired boy, "You sure do look like a girl. I'm gone take you home and spole ya!" He and his brother wore sneakers that lit up when they hopped, which they did a lot of, and their harried young mother, tapping her Camel Light into the tinfoil ashtray, said, "You can buy 'em if you like 'em. Thirty-five cent for the blond, quarter for the dark one."

"How you feel?" Fat Boy asked me as I settled by the sheet-plastic door, and before I could answer, he stuck out his paw. "You can feel *me*, see how *I* feel, you want." A joke.

The waitress from the dining car came in and plopped down, lit a cigarette.

"How you feel, Mary?" Fat Boy asked her.

"My feet hurt."

A bald young man on the opposite bench laughed, maybe just getting the how-you-feel joke. His head was shaved so close the stubble shone like a veneer of black polish on his grey skull. His name was Pete and he was from Denver.

I took out my pack of Petit Nobel Sumatras, and Fat Boy looked at me. "What 'choo do?" he asked me.

"What do I do?" I said.

"He's a lawyer," said Pete, watching me with small black eyes.

It seemed perhaps not a good thing to be considered a lawyer here, so I said, "I'm a writer."

"Well Stephen King's a writer!" exclaimed Fat Boy.

I considered telling him I was on my way to read a story at a public college in Chicago where there had been a recent uproar over a Picasso sculpture on display there. It was a cubistic sculpture of a woman, and someone suddenly noticed that one of the woman's breasts was larger than her cranium. I had also been requested to delete a sentence from the story I was to read. The sentence in question, "God is a cunt," seemed thematically appropriate to the story, and I had not yet decided whether to delete it from the reading. I wondered what Fat Boy would say to that.

"You ain't from here," Pete said, and I told him I lived in Denmark. "I know a writer from Denmark," he said. "Guy wrote about America, visited all the black towns and all. Took pictures. Good ones. Jacob Holt."

Tampa Fat Boy's eyes turned on Pete. "What 'choo do?" he asked him.

"Just outta jail," said Pete.

"What for?" Fat Boy demanded, red eyes level.

"Drugs."

"But you clean now. Ain't you glad you clean now?"

"Glad I ain't in jail, not glad I'm clean."

"People take that shit," said Fat Boy, "they put a gun in anyone's head to get a fix."

"I'd put a gun in *your* head," Pete said.

"And I kick wax out your ears so *fast*," Fat Boy shot back.

They locked eyes while I busied myself lighting a little cigar and chatted with a young woman beside me from Vermont, about her trouble getting work even with a master's degree. Then Fat Boy was talking about gay motels in Florida and clothing-optional clubs. Something must have crackled between them for soon they were on their feet, shuffling out in tandem. I saw the two of them in the aisle squeezing into the restroom together and decided it was time to retire.

Now, at the smoke stop outside Greenwood, I wonder what the friendly brown-faced woman might think about that, but suffice it to say the smoking quarters on Amtrak are miniscule.

"Oh that different now," she says. "Now they got a *whole* section. It closed in but you kin sit in comfort. Even got *music!*" she says playing the word low, with a throaty chuckle and a shy, self-ironic smile, smoke drifting from her short broad nostrils.

The young man named Marvin comes sidewise between us, folded stiffly forward like a half-opened jack-knife, palms joined. "I truly do not wish to be a trouble, ma'am," he says softly to the brown woman, "but I am very unsure where I got to change the bus and what I got to do. I fine myself confuse."

"You goin' to Beaufort, right?" she asks. "We take care of you."

"Yes, ma'am. I got two children there. Two girls. I just love 'em to death."

If he's been in jail since he was 16, he must have started a family about as soon as he was able. Nuptial visitation rights maybe. "I'm going to Beaufort, too," I tell him. "We change in Savannah in about two hours and have about an hour's wait. I'll show you where we have to get the bus." But the young man looks pointedly away from me. It occurs to me I have no real idea what he was in for or what horrors he might have experienced of seven years in stir, to what extent the contemporary mythology of American prisons is grounded in fact, or for that matter, such being the prejudices engendered by suspicion, what kind of metal he might be carrying in pocket, shoe or other cavity. "I'll let you know when we have to change," I say again, attempting to clarify whether he simply hadn't realized I was addressing him, but he continues pointedly to ignore me in my necktie and Stetson hat. I think of prison films I've seen, of Jack Abbott's *In the Belly of the Beast* and the knife he stuck into a Greenwich Village waiter when he got out, about Tom Wolfe's *A Man in Full*, the racial division depicted, and I shut my mouth.

The brown woman pats the boy's hand and repeats, "We take care of you. We see you come no harm." It occurs to me she is a natural leader, a person who inspires confidence, who exudes the qualities of true leadership and consideration for justice and the rights of all. It seems to me it would be wonderful to *be* her, strong and clear of nature. I wish that I

could talk more with her, learn more about her life. She seems to me the salt of the earth, but I will only be allowed this small glimpse during a smoke stop.

"This *is* the correct bus for Beaufort?" asks Marvin once again, and I remember how confused I was at 23, how I bounced all over the country during the 60s and more than once came this close to doing time for possession of marijuana in Ohio, Texas, Arizona—a lot of time it would have been. I literally cannot imagine the terror that would be entailed in seven years locked up from the tender age of 16, or from 23 for that matter. Marvin's question hangs in the air and is picked up by a very large white man in his early thirties. "All I know is it's headed for Jacksonville," he says with a grin meant to savor his own lack of concern for anything but that fact. "The rest of ya are on your own!" A good six-seven, he must be carrying three hundred plus pounds in his biceps and legs and chest and neck. The only thing small about him, incongruously, are his hips and butt. His naked skull sits in a socket of rippling fat and muscle, and both biceps are adorned with huge laughing devil heads from whose tattooed mouths extend long, serpentine red tongues—faded, two-color, institutional jobs. On the back of his sawed-off tee shirt is printed in large block letters, *I'M THE BIG DOG.*

I'd listened earlier to his conversation with the bus driver whom he'd asked for advice about how to get work. "I'm moneyless, jobless, pretty soon homeless too."

"Work for the government, why don't you!"

"Can't. Got three convictions on record. Misdemeanors," he added to my and no doubt everyone else's relief. Disturbing enough to consider the weight of a misdemeanor this hulk of a man might root from the earth, let alone a felony.

Soon we are queuing to reboard the dusky bus, and the woman says quietly to me, "Will you help that boy find his way to the connecting bus in Savannah? He got two babies waitin' for him in Beaufort." She reaches forward to young Marvin. "You stay with this gentlemen, hear? He goin' to Beaufort, too. You stay with him."

"Yes, ma'am," he says and climbs aboard without a glance back at me.

Through the early January twilight of Highway 25 we roll, through Edgefield, Trenton. The code of the Greyhound strictly forbids smoking, alcoholic beverages, and aggressive behavior, the driver announces over the sound system. "Or disturbing the driver," he adds. To mellow the gathering dusk, I sip from a plastic Vittel Grand Source water bottle full of Stolichnaya, remembering the Mason jar of white lightning I drank the week before with a friend from Kentucky. I was determined not to disgrace my Yankee self, managed to stay upright in my chair through the whole quart. Next morning, while I lay wrapped in painful respect for southern home-burnt, he phoned and said, "Tom, you did real good last night, and I'm thinking, Whyn't I come on over and we do another Mason jar?" My horrified silence ex-

tended sufficiently to rip a roar of laughter from his throat: Thank god, it was a joke.

Spanish moss hangs in narrow wispy drapes from the gnarled, reaching limbs of the Live Oak trees and magnolias and whatever else on which it can find purchase. To provide a hostel for mites and the eggs of palmetto bugs, the genteel southern nomenclature for what we in New York used to call cockroaches. But New York roaches are hardly a match for the Sherman tank of the southern palmetto bug. In my adopted city, Copenhagen, I've never even seen a cockroach, though in wet weather, crickets sing from beneath the floorboards in the living room of our ground-floor apartment.

The moss is lovely in the sinking light of the sun off the highway to my right, in the spell of the vodka.

We roll past an El Cheapo gas station, Best Western, Quality Inn, Econo Lodge, Relax Inn, Sleep Inn, Pizza Hut, McDonald's, Wendy's, Amoco, not much one-of-a-kind left. We turn down the main street of some side town, pass a shop window exhibiting a Support Our Troops display, a toy shop selling cop uniforms for kids. A sign offering Venus Pie makes me smile; then comes a poster of a bearded Swami suggesting that one learn to meditate. On past a lot and yet another store called Venus, this one with a decaying side wall. Hub City Finance. Mack's Finance. Main Finance Loans. Palmetto Finance. Palmetto Loans. Vein Clinic. Hi-Style Fashions. First Baptist. Flammable Keep Flames Away. And a sign that says, *Injured? Law Offices of Lee &*

Smith. It occurs to me that Lee & Smith might extract compensation for the hurt of a Smith & Wesson.

Then there's a road sign offering Psychic Readings, another that says *Speedy Jail Release – Call Tony Sampson*, the neon palmetto of a sign advertising *The Palmetto Loan & Finance Company* and *Paychecks Cashed Here.* Strange to think there are still people without bank accounts, who have to pay a fee to cash their paychecks.

Past the Olivier Gospel Mission is a Comfort Suites motel that looks like a red brick prison. In the setting sun, flags are being lowered—the attractive navy blue flag of South Carolina with white palmetto and crescent moon, the stars and stripes, and the cross-barred flag of the CSA which flies with the others, sometimes alone—a flag the NAACP is working to have banned from the state capitol building.

I recall as a boy on mid-50s Long Island how we used to *play* Civil War, switching grey and blue caps, how somehow quaint that war, nine decades behind, managed to seem to our unreflecting minds; not challenged to reflect on other than war's glory, we imitated bright tin troops who fought, Sister Mary Redemptress for some reason felt called upon to emphasize, *not* to free the slaves, but to preserve the Union. How startled I was years later to learn how true her words were, how secondary the issue of slavery was to Honest Abe.

There is still enough light to glimpse a cemetery to the left of the highway, a vast field of tiny stones. As we pass the Central Assembly of God, then a club promising *All Nude*

Girls and another that promises service by *The Same Great Fully-Clothed Staff As Always*, someone moving down the aisle bumps my folded knee—a tall slender young black man. "Excuse me, sir!" he says with an apologetic smile, and proceeds toward the driver.

"Pardon me, sir," he asks softly, bowing toward the back of the driver's lined ruddy neck. "Are we headed for North Augusta?" The driver does not reply, and the man asks again, less softly. Still no answer. The young man stands up straight, looks around him with eyes that break my heart, turns to Big Dog and repeats his question. Big Dog sits up stiffly and says with formality, "I believe that is one of our destinations." Then adds, "That is, *North* Augusta, *South* Carolina."

I think of Alice whom I've left behind at Converse College in Spartanburg, a gun-free, drug-free school zone, where she is working in the art department with a number of other women artists, in the department headed by Mac Boggs. Mac had introduced us to the work of some local Outsider Artists—what Jean Dubuffet called *Art Brut*. Among the pictures in Mac's collection was an oil painted by a man who lived in the Kentucky backwoods, depicting a bearded central figure with arms opened in embrace or revelation to indicate, among other things, an airplane crashing into a skyscraper and figures leaping from buildings. The painting had been done prior to 2001. The bearded figure might have been

Jesus. Or it might as easily have been Osama Bin Laden. A mystery.

It is dark when we pull into the station at Augusta. Even if state lines are arbitrary and invisible, I feel a little thrill being in a new state, the state of Georgia. I think of delicious juicy August peaches and the gators and panthers of the Okeefenokee Swamp and hear Ray Charles in my mind singing, *Just an old sweet song, keeps Georgia on my mind...*

The mother of a very young baby I'd heard crying from behind me on the bus, a cry I'd at first taken for the yowl of a cat, joins the clan of puffers outside the coach. Her face is red and wrinkled.

"Sure good with a smoke, ain't it?" she says with a smile that is minus a left incisor. I wonder if it was knocked out by her husband, a surly, bearded man I'd heard arguing with the ticket vendor in Greenville. Tall and lean with a scowling mouth, he slept toward the back with his cap over his eyes and legs across the aisle so you had to hop over them to use the loo. But now he is on the bus watching the baby whose mother tells me she's been riding 40 hours for Jacksonville where her parents have offered shelter for 120 days so their little family can get up on their feet. "I'll get up on my feet," she says, and I remember the fear in her eyes as her husband punched the counter and berated the Greenville ticket vendor who told him the machine had rejected his credit card.

In the little terminal, a short heavy black man with black moustache and Vandyke beard, carrying a case of plas-

tic coke bottles on his bald head, walks past hollering, "Matthew! Matthew! You spose to be here seven pm don't you know?" I glance at the bus schedule notice board and smile to see a bus is scheduled at 5:30 a.m. for Denmark—that's Denmark, South Carolina. The sweet brown woman who is the salt of the earth has left us in North Augusta, and young Marvin now stands close to me.

"We all still on *this* bus, right?" he asks.

"Right. To Savannah. I'll show you where to change." I offer a cigar. He stares at the little open box. "No, thank you, sir. They too...they too..."

"Strong?"

"Yessir." He takes out a crumpled, near-empty pack of Newport menthols and asks for a light which he accepts without thanks.

"Understand you have two children?" I say.

"Yes, sir."

"Boys? Girls?"

"Girls, sir. Five and three." He smiles. "I just love 'em to death."

I try to do the math but fail. Perhaps they do have nuptial visitation rights wherever it is in Michigan he was in prison. "Sweet age," I say. "Five and three."

"Yes, sir, they sure are."

Greyhound routing is such that to get to Beaufort, South Carolina, from Greenville, South Carolina, on this particular day, we have to ride south to Savannah, Georgia, wait an

hour, then catch another Dog running north along the coast another hour back up to Beaufort, South Carolina.

The elegant art deco facade of the Greyhound terminal at 109 Martin Luther King Boulevard in Savannah speaks of the 40s when bus travel was still mainstream. I think of Steinbeck's *Wayward Bus* and Marilyn Monroe in *Bus Stop*. Inside, the terminal is shabby. Where once would have been a good American diner is now a Wendy's, and we learn that our connection is delayed by 45 minutes. At the chilly doorway, a shirtless, leanly muscular white man with two missing front teeth and neo-Celtic tattoos up and down his arms and chest tells us with a grin that his bus to Jackson has been delayed for *twelve* hours. He tugs up his jogging pants and nods jauntily at me and Marvin as if to say, "Now *that's* a delay." A black driver in grey uniform looks at the man's ticket. "This here's for Jackson, *North Carolina*. You ticketed to Jackson, *Ohio*."

"Shee-it," says the man with his imperturbable grin and hitches up his joggers. I wonder if he is just proud of his torso or doesn't own a shirt. Maybe he gave someone the shirt off his back. Preposterous as it may seem from his appearance, he has an aura, strikes me as someone who a century and half before in Russia would have qualified for canonization by Dostoevski.

In the Wendy's I buy a container of coffee and a cheeseburger in greasy paper and watch a couple and two children sit down to their bags of junk food, bow their heads in grace.

Marvin asks if I will watch his shoebox and paper bag while he goes to buy a can of orange soda from a vending machine. A warning printed on the side of my paper cup of coffee advises me that it is hot.

I am excited about the stop in Savannah where I've never been before, one of the most beautiful cities in North America—where an 11-year-old Conrad Aiken, author of one of my favorite stories, "Silent Snow, Secret Snow," listened from the next room while his father, the doctor, shot his mother, then himself; birthplace of Johnny Mercer, grandson of a Confederate general, who wrote one of my favorite songs, "The Summer Wind"; where Flannery O'Connor grew up in a house on Lafayette Square; where Charles Wesley wrote "Hark the Herald Angels Sing"; where Julliette Gordon Low founded the Girl Scouts of America in 1913; where all the alluring exaggerations of John Berendt's *Midnight in the Garden of Good and Evil* unfold; where Martin Luther King first delivered his "I Have a Dream" sermon at the Second African Baptist Church on Green Square. But our stop there is too brief for sightseeing, and it is too dark now to see anything on the road, so I lean back and half doze, half eavesdrop on a conversation somewhere behind me. One man is telling another he just did four months for a DUI. "Third time. Wouldn't let me pay no fine. I tell you, I ain't goin' back to that bullshit."

"Third time?"

"Ain't goin' back to *that* bullshit. Wouldn't happen to a white boy."

From Savannah we head north on 95 through Hardenville and Ridgeland. Invisible to our right, south-east, is Parris Island, the infamous United States Marine Corps boot camp whose graduates form a fraternity which perhaps most American men who are not, on some level regret not being a member of: *Semper Fi.* I think of Andre Dubus II, who resigned his commission as USMC Captain to join the Iowa Writer's Workshop in the 60s. And Lieutenant Dave Mix who lost a foot in Vietnam and wrote a fine novel about the teenagers sent to fight that war, titled *Intricate Scars*, that nobody would publish. And Mike Lee, two purple hearts from the Nam, who had an American flag thrown in his face by an irate pacifist when he got off the plane in San Francisco and whose recently published collections *Paradise Dance* and *In an Elevator with Brigitte Bardot* are tucked in my carry-on. On a drunk and disorderly charge, Mike had been given a choice by an Oklahoma judge of jail or two years in the Marines. He was seventeen.

In the dark the bus crosses many bridges joining many islands—Hunting Island, a jungle in which the Vietnam War scenes of *Forrest Gump* were filmed, the revisionist movie that blithely skirted discussion of whether we should have been there, and St. Helena, where at Penn Center Martin Luther King wrote "I Have a Dream" and where I once purchased a Bible written in Gullah, Sea Island Creole, an 18th

century language compounded of plantation English and several African tongues (the Gospel According to Luke: *De Good Nyews Bout Jedus Christ Wa Luke Write*); Lady's Island, and Hilton Head Island with its gated community, where the people who will host my reading the next day reside.

At Beaufort's tiny Greyhound terminal, two women and two girls are waiting to greet Marvin who has donned a white stocking cap for the occasion. His step is light as he swaggers into their embrace, a fine-looking family. Their battered Ford is parked out back in the little lot. I stand at the door looking for my hosts, and Marvin turns back to me. He places the palms of his hands together and bows his head. "Thank you for your kindness, sir," he says. "Thank you."

I wish him luck and watch them pile into the car and back out. Their power steering needs fluid, I think, and watch as the car squeals and turns out of the lot, putters off into the darkness. A few moments later, a black Mercedes SUV pulls in, and my friends, Rick and Rikki, hop out with friendly exclamations of welcome.

With a gentle, incredulous smile, Rick says, "You took the *bus*? I haven't been on a bus since I was 20!"

"I *never* have," Rikki says, laughing.

"Why the hell didn't you rent a car?" Rick asks. "You could have been here in half the time. Less!"

I smile and climb into the redolent black leather seat of the Mercedes and listen to the silken purr of the motor as we back out through the dust of the lot, headed for the gated

community of Hilton Head. A few blocks up we stop for a light alongside Marvin's family Ford. I see his white stocking cap at the window of the back seat. He does not recognize me.

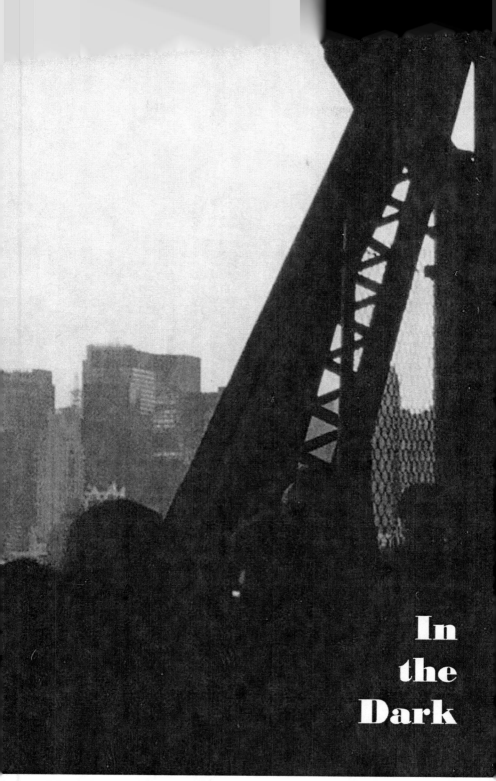

In
the
Dark

STEAMING NEW YORK AUGUST AFTERNOON and my sister's air-conditioner abruptly shuts down. Frank Sinatra stops singing mid-phrase from the stereo, *The summer wind / came blowing...* The refrigerator is not humming. I pop the door: no light.

Familiar signs. I still remember the blackout of '65. That time I was on my way home to Queens from Manhattan, in the subway at Grand Central Station, when the doors of the IRT train froze halfway shut and the subway station went black. I followed a man with a Zippo torch through the dark and up to the street, weird in its darkness, lit only by head-lights. I walked across the 59th Street Bridge and hitchhiked home to Jackson Heights. At the Queensborough Plaza foot of the bridge I literally invited myself into a car stopped at a crowded, lightless intersection and was welcomed in without ceremony, driven within two blocks of my door.

This time I will have to reverse the procedure. I am in from Copenhagen, visiting my sister in Bayside, and my ho-tel is in Manhattan. The Hotel Carter, $89 a night, same ho-tel that Jon Voigt stayed in as Joe Buck in *Midnight Cowboy* back in 1969. Which does nothing to help my situation. I'm due to fly out of Newark tomorrow night. The geography of the Queens roadways have changed; after years in Europe I no longer know them. The Long Island Railroad is out, the

telephones are useless, and there are no taxis to be had. So I set out on foot, my sister's kiss warm on my cheek, toward Northern Boulevard.

I stick out my thumb. At once, a Chevy convertible stops. "You look like a gentleman," the sweet young woman behind the wheel says warily, eyeing me, clearly considering whether to take the chance. How times have changed since the '60s when I logged a good 30,000 miles on my thumb all over the country; serial murder had not yet become a national sport. But she opens the door. In the three miles to Northern, we exchange life stories. Hers already forgotten, I catch a bus for Main Street. I have only 47 cents in change, but the driver waives the exact-change requirement. From Main, I walk a mile through festive confusion along Roosevelt to Junction Boulevard, fortunately missing the mass of disappointed Mets fans boiling out of the Stadium, climb aboard another bus whose fare box sports a hand lettered sign: *No Fare Required.*

I stand shoulder to shoulder with the crowd in late afternoon August heat as the bus bumps along Roosevelt beneath the tall steel structure of the El train. In a New York blackout strangers chat freely. The fellow sweating close beside me is an exchange student from Estonia attending Queens College.

"*Terviseks!*" I say, an Estonian toast, and he tilts his head in understated incredulity. I find myself telling him everything I remember about his country which is not a

great deal; I was there in the beautiful ancient capital of Tal-
linn one winter day a few years earlier. It was snowing. I ate
caviar in a restaurant and drank big glasses of icy vodka. A
contingent of the Russian mafia burst in, three men in dark
suits with gold-capped teeth, impossibly beautiful prostitutes
on their arms. The waiter pulled a curtain around them into
which he kept feeding bottles of champagne. Outside in the
snow the sky was red, crossed by long thin strands of white
cloud; it looked like the Danish flag, which, according to tra-
dition, fell from the sky here some medieval century into the
hands of some marauding crusader king. I tell about the nar-
row escape on my way back to my hotel from a man enthusi-
astically offering to sell me his body. "You, my American
friend: My body, 200 crowns. Okay, okay, last offer: My
body, 100 crowns! *Fifty* crowns!"

My young Estonian bus-mate seems amused. He speaks
English like a Finn, slowly, with dry goodwill, pauses be-
tween words. "Is better here," he says.

"When the lights are on."

"Is still better."

Then we are at 61st Street in Woodside, end of the line.
The crossing is in turmoil. I try to convince a cab driver to
take me over the bridge, but he just shakes his head, smiling
ruefully. I can't be certain he understands English. The shop
fronts are studded with signs in Korean, Indian dialects,
Spanish. On the avenue, I flash my thumb and a four-ton
truck stops. Crammed in the cab are three Latino men who

motion me to the back of the cargo container where a crowd of multicultural hands reach down to help me in. As the truck jerks to a start, I begin to fall backwards. The hands catch me from what might have been my death beneath the wheels of the truck behind us. All smile in quiet appreciation at their quick-witted heroic accomplishment. I try to express adequate thanks with the blue of my eyes, hand on heart, relishing how I will tell this tale of near annihilation to Alice when I get home to Copenhagen. *If.*

At the foot of the bridge, a policeman stops traffic on the lightless streets to help an ambulance through. Only traffic out of Manhattan is allowed onto the Queensborough Bridge, aka the 59th Street Bridge, the parenthetical subtitle of Simon & Garfunkel's 60s hit, "Feelin' Groovy." The other traffic lane on the bridge is choked with pedestrians fleeing the city. I climb onto a waist-high green-steel abutment platform and start across against the stream. Sweaty smiling people, bare-chested or in undershirts, wave and shout encouragement and greetings to me from the walkway and roadway. Across the river the jagged teeth of unlit skyscrapers begin to grow dark against the setting sun behind a chainlink fence.

I still have a couple of shots in my camera and stop to take a picture of the darkening city. A young muscular black man passing beneath turns to walk backwards, shirtless, and pump his fist approvingly, the river flowing and swirling below in the thickening darkness, flowing like a bent pin,

gleaming rusty in the last of the sunset, toward the narrow foot of the island. The city beside the river resembles a reclining Buddha, massive industry transformed suddenly to pensive amusement; the ant heap takes on its god-like form, observing the ants, not without approval, not without encouragement.

Soon I am off the Bridge, heading west across Manhattan. The only light on the streets is from the headlights of automobiles and buses. The windows of the tall buildings are dark, the streetlights dead. For a moment the prospect of crossing the avenue seems terrifying, but I plunge out into the road, and the cars and trucks and buses stop. There are no angry faces. Everyone understands. New Yorkers thrive in crisis.

It is eerie in the streets. Shadowy figures everywhere, huddled against walls, in doorways, alone, in clusters. It makes me think of Hawthorne's Goodman Brown wandering into the woods at night alone only to see there all the townsfolk lingering in shadows, behind trees. There are police officers at some of the crossings, and people wearing strange green luminescent devices around their necks pitch in to direct traffic. Here and there a group of policemen and policewomen stand chatting, hips fat with guns and clubs and handcuffs and citation pads. Alone, against one tall wall, leans a black policewoman a head shorter than myself, which is pretty short; I'm only five-seven. Staring noncommittally into my eyes; she is at once thick and shapely, and her Fellini

-like sensuality arrests me. I move on, feeling I have abandoned a portal to some weird dimension.

There are police everywhere. Although I do not for a moment fear that this blackout was caused by an act of terror, I will later learn that many thousands of extra police were called to duty as part of the city's anti-terror plan as soon as the lights went out.

In a doorway off Second Avenue, a young woman huddles with a dark-skinned, fine-featured three-year old girl who looks like a *Cosby Show* stand-in. The woman is Hispanic, in her early twenties, pretty, her fright evident beneath the impassivity of her face.

I stop. "Can I help?"

"I carried her all the way down from 135th," the woman says. "She's thirsty." Her eyes search my face. "Someone grabbed my butt in the dark."

It occurs to me that we are only three or four blocks east of the Plaza Hotel. For some reason, the Plaza seems a haven of civilization. Many times in my life I've sought refuge in its elegant lobby, wandered in once in the mid-60s at six in the morning after an all-night existential crisis because the Plaza made me feel safe. I must have looked a sight with a smell to match, though no one challenged my presence. No doubt, eyes followed me with keen discretion, but I was allowed my hit of security unchallenged. Surely the Plaza is where to go with this young mother and her thirsty baby. I picture the three of us at a candlelit table in the Oak Bar, the woman

and her baby with cokes, cool water, a lemonade perhaps, a melting dish of ice-cream, me with a magnificent Oak Bar martini shaken expertly by Orlando Rivera, who has served me many times before. We could share an Oak Bar shrimp cocktail—shrimp the size of small lobster with spicy red horse-radish sauce—as I had with Alice on her 60th birthday when we flew to New York for the occasion, her first taste of the Apple. I remember decades before, my father telling how he sat there over a drink with Raymond Burr, getting him to sign a cocktail napkin which he brought home to Queens as proof he'd had cocktails with Perry Mason. I think of the huge, cozy, American impressionist painting on the bar wall, showing the city in a snowstorm, top-hatted men leaning into the wind, a hansom cab driver's whip blown back above his head. The Plaza has always, all my life, seemed a welcoming place to me, associated with Salinger's Holden Caulfield, Willa Cather's "Paul's Case," and of course with Kay Thompson's fictional little girl, Eloise, who lived up on the top floor with her nanny and upon whom care and attention were lavished by the Plaza staff, whose portrait by Hillary Knight has hung in the lobby, and who is commemorated by a brass plaque at the hotel door proclaiming it "The Home of Eloise." Reality co-opting fiction via concrete artifacts.

What better place to bring Chanel and little Kyla? I offer to carry the baby; without hesitation she climbs into my arms, leans her marzipan face against my chest.

"I been in the Air Force," Chanel tells me. "Kyla's dad was, too."

"Where is he now?"

"Gone," she says. "Like my own dad."

"Where do you live?"

"Twenty-third Street." Her eyes sweep toward me, nervous with apology. "We in a shelter for a while."

At Grand Army Plaza, men and women sit around the edges of the fountain and on the stone benches. The rank of Hansom cabs stands at the ready as always, wrapped in the heady smell of horse, and people mill about outside the Plaza's darkened entry. On the steps to the lobby, ranged across the center, stand a white woman and a hotel-uniformed black man wearing name tags. The woman's smile has an unmistakable edge of strained PR. She looks like a *Saturday Night Live* caricature, but she is for real. "What is your room number, please, sir?" she asks as we start up the steps.

"I don't have a room. But this young woman and her baby are very thirsty. I'd just like to buy them something cool to drink."

"I'm sorry, sir."

The uniformed man is tall and broad above us on the steps. He watches me. His name tag says *Washington.*

"You're not really going to turn us away? This baby is thirsty."

"I'm sorry, sir." She smiles when she says it. Washington does not smile.

Across Fifth, just over from the Sherry Netherlands, we sit on a low stone wall, and I buy bottles of water at uninflated prices from a Sabrette's wagon. The water is still cool. What a cliché the contrast of the Sabrette man's friendly, brown-faced smile seems here in the dark crowded hot street, across from the hotel where Gatsby's Daisy was so at home and where Robert Redford stood with an enormous American flag at his back, distancing himself from Barbara Streisand picketing against atomic weapons in *The Way We Were*.

Of course it is unreasonable to expect that great establishment to take pity on an insignificant woman and her baby and insistent escort who could not produce a room number. What if everyone insisted on being let in? I have no case. Yet I doubt I will ever again feel quite the same about the Plaza, home of the fictional Eloise that couldn't spare real-life Kyla a lousy glass of water.

I play "Round and Round the Garden" with Kyla. "Like a teddy bear. One step, two step: Tickle you under there!" I touch her under the chin, and she giggles, hunching up her shoulders.

"Unner there again," Kyla says.

"Now we've had this adventure together, we have to become pen pals," Chanel suggests.

I give her my card, and she prints her cell phone number on a torn-out sheet of spiral paper for me. We walk together

down Fifth, Kyla on my arm, and I help them into a bus at 48th, watch it edge out into traffic and roll off down the dark avenue toward their lodgings in a shelter I cannot imagine, feeling helpless and unresourceful and useless.

When I pass the Marriott and see people sitting and lying on the sidewalk and being turned out of the lobby, I begin to assess my own situation. Abruptly it occurs to me that a wallet full of dollars and platinum credit cards might not be a safety net in this situation. How the hell am I going to get up through the black stairwell to my room on the 21st floor of the Hotel Carter? How am I going to do a simple thing like take a pee, the mere thought of which makes me instantly feel I have to do.

I walk west on 43rd, loop south. A shirtless man stands still in the middle of the sidewalk, nodding, eyes closed, blood running from his nose. Further along another man lies on his back against a wall, alongside a gutted television set. He looks dead. Why do I simply walk past these people? At 42nd and Times Square, the Great White Way is dark. North again a block and across the street from my hotel, a handful of people stand in the darkened doorway of the New York Times offices.

Even when the power is on, the tall sign that climbs the Hotel Carter wall is missing letters: HOTE CAR E. $89 A NIGHT. Now *all* the letters are dark, and I *really* have to pee.

A man I do not recognize sits on a chair outside the street door of the hotel. Abdul the night manager stands beside him, swathed in his natty blue blazer, flashlight in hand. "He is okay," Abdul says, referring to me. Inside, the broad dim lobby is lit with candles. A Chinese man in a white shirt holding a flashlight seems to be in charge here. I tell him I need to use the gent's.

"Go up to room," he says. I explain to him that I do not intend to climb 21 flights of stairs in the dark to take a leak. "I have to pee *now! Here!* Please accompany me with that flashlight. *Now!*" At the door of the gent's, I wonder whether he intends to stand beside me shining the light on my business, but he mercifully passes me the flashlight and waits at a discrete distance in the dark.

Outside on 43rd Street, I sip a bottle of water, leaning against the hotel wall. In the narrow strip of dark sky between the buildings hangs a huge bright full moon, pure as a Holy Communion wafer, and two tough-looking black kids saunter up to the man on his chair stationed at the door.

"Got any rooms?" one asks.

"Full," the man says without looking at them.

The two move on, grumbling, loiter a few yards down by the curb in the shadows. A moment later, two young women ask the same question about rooms and are admitted. The black kids step out of the shadows. "See that! If we was white you give us rooms, too!"

"*Full!*" says the man at the door.

Abdul moves over to me and asks how I am.

"Wondering where I'll sleep tonight," I say.

"You can sleep in your room. I walk you up with my flashlight. I already been up and down ten times. You get up there, you open your windows, get a nice breeze." He smiles. "Are you not glad you choose us over Marriott?"

"Over the Plaza, too," I say and follow his beam of light all the way up the long, zigzagging flights of the strange dark stairwell.

Abdul is right. Not only is there a breeze, but stars. When, I wonder, did I ever see stars in the sky over Manhattan? Not only do I have open windows, a breeze, stars, the moon, cool running water in the bathroom, a flush toilet beneath a window that admits sufficient moonlight to allow me to see where I pee, but on top of all these advantages, my cell phone rings: It is Alice, calling from Copenhagen. How in the hell did she get through? The nets have been jammed all night!

"I just keep trying," she says, and I have the solace of her sweet voice as I lie naked on the cool sheets, my tired legs stretched out, toes wiggling in the cool night air.

Reluctantly we say goodnight. In the dark, hands behind my head, amidst the battered mismatched furniture of my Bogart-noir room, I think again of Chanel and Kyla. Her cell phone number on a crumpled piece of paper is in the pocket of my shorts, slung over the back of the plastic chair. What good would it do to phone her? What could I say? I could

invite her and the baby to breakfast tomorrow? Why? The moment of our meeting is past. I know we will not be pen pals. The crossing point of our lives is behind us. I dial anyway, knowing it is futile. The lines are jammed.

In the morning the juice is still off. I look out my bathroom window over the dark-windowed buildings toward the Hudson River, sliding beneath the misty early light. Though my room is lit with daylight, I had not considered the fact that the stairwell is blacker than darkest night. A terrifying place to be. And no way to contact Abdul to come light my way down. Nothing to do but feel my way to the banister and clutch with both hands, one-step slowly down, rounding the landings after each flight, losing count of the floors so I don't know how far I have left to go, hearing voices speak Spanish somewhere below me, hushed voices, furtive perhaps.

It is too late to go back, and no sense in bailing out at some random floor, nothing to do but keep going, feeling gingerly with my feet for solid ground. I revert to my army training and do the night walk. One hand extended before me, feeling with the toe of one foot for fast terrain before bringing the other foot forward. But in the army you also had your rifle and fixed bayonet to hold out before you.

Just about then the paranoia clicks in, like a lump of ice in the pit of my stomach. It is not only the fear of a misstep, of falling, it is the terror that someone else is there in the stairwell, back to the wall, listening for me, breathing in the

dark beyond my ken, beyond my reach. Or not breathing. Waiting. I even think about those two tough-looking black kids the doorman turned away the night before. What if they got in somehow? Originally all they wanted was a place to sleep. Now they want revenge. I picture them there with knives, eyes attuned to the dark, aware of my presence, waiting to grab me, to turn me into one of New York's two-murder-a-day statistics. I am ashamed of these thoughts, this fear, but the emotion is strong, a dark angel I have to wrestle with. Sweat trickles down my back, from beneath my arms, rolls from my brow causing my eyeglasses to slide down my nose. Jesus, what if I drop my glasses? How will I ever find them again? Without my glasses I'm half blind even in the light.

This is nothing, you wimp! Pull your scared ass together and keep counting those steps! One, two, three... Sixteen steps to each landing, then a little group of sometimes two, sometimes three steps before the next flight begins.

Finally I see daylight below and I am out in the lobby. Abdul is slumped over his desk. "Damn!" he says. "I been up and down those stairs all night!"

"At least you got a flashlight!"

"Where you go?" he asks me.

"To get a flashlight!"

"No flashlight nowhere!"

But I am determined. Even the free ice cream being doled out by Ben & Jerry across the street does not deter me

from my mission. I will have a flashlight. I will not spend another night without a flashlight. Nothing in the world then seems more valuable and essential than a flashlight. And of course, everywhere I try is sold out, every electronic gadget shop and computer center and department store, those that are open at all, cash and carry only, credit cards need electricity, all sold out. There is not a flashlight to be had in the city. I walk for an hour, two, east and west, uptown, downtown past a man sprawled asleep on a bench, uptown again, through hell's kitchen, past a sofa on the sidewalk of Eighth Avenue where two young black men wearing stocking caps sleep—perhaps the same two turned away from the Carter the night before, past a dusty hell's kitchen window where two skinny cats watch me pass, into a second hand shop. No flashlights. Sorry. Have a good day.

The thought that the lack of power might continue, that I might not get out of the city on schedule, that I might have to stay another night in the Carter negotiating that black stairwell up and down, at the mercy of others with pocket torches if I have to use the Gent's—the thought of all that as I wander through the boiling August light of late morning tickles in me like the edge of panic preparing to take hold and shove me off the deep end. *Pull yourself together, you fool!*

Finally, then, on 44th, between Sixth and Seventh, in the basement of an All Items 99 Cents or Less store, I rummage through an abandoned shopping cart loaded with items someone seems to have decided not to buy after all; I find a

flashlight. It is a beautiful thing, solid, elegantly rubberized, about eight inches long. There are batteries in it, and the beam is strong. Unfortunately, its packaging is gone, and there is no price on it. There is something suspicious about it. I pick out another item—a cheap knapsack with a price tag on it, reasoning it will make my purchase more plausible, a man who buys *two* things is less suspicious than one trying to buy a coveted, unpackaged flashlight. I go to the cashier. Here there is electricity for they run on their own generator.

"I'll have these two items, please," I pronounce with all the authority I can muster.

The young Hispanic woman at the register rings up the knapsack. Then she turns the flashlight over in her hands, inspects it. "This the store's, I think," she says. "This the store's. You cannot buy this."

"It was there amongst the wares," I say forcefully. "It was offered for sale on the shelves, and I intend to buy it."

Our eyes meet. I do not blink. I do not smile.

Then she says, "Okay I sell you. This is emergency. I sell you." And rings up $1.99 for this beautiful, priceless, essential piece of survival equipment. It is black with a thin yellow band around the lighting unit, to indicate where it unscrews to replace batteries or bulb (ingenious!) and a yellow on/off switch with a thumb skid molded into it to keep sweaty thumbs from slipping (brilliant engineering!). Along the battery tube in black letters are embossed the words, *POWER PLUS*. (Indeed!) And to a little metal ring in the

base is fixed a slim but strong loop of black nylon cord to hang the instrument on a peg or on a belt loop. It is a most congenial flashlight, hefty without being burdensome, a pleasure against the palm of the holder, a marvelous machine.

Parched and elated, I enter a corner bar on Eighth and 44th, illuminated by natural light through the plate windows. Someone has the news on a transistor radio from which an amused reporter is telling how Mayor Bloomsberg has assured the populace that crime is continuing at a normal rate. The long bar is full, but there is a seat for me, and I order a Heineken.

"It's cold!"

"Indeed it is," says the smiling barmaid. "We kept the refrigerators closed."

"And what part of Ireland are you from, Eileen?" I ask, reading her nametag.

"Dublin," she says with a pleased smile. I lean closer. "Know what I have?" I say to her *sotto voce*. "A flashlight. Look." And I lift the beautiful tool from my knapsack. "See?"

"Surely it is a beauty," she says and moves off to another customer.

Everything is good again. I want to tell the patrons sitting to the right and left of me that I have a flashlight. A *flashlight!* I want to tell them how I hunted it down and procured it with guile and firmness, overcoming all obstacles. I

deserve this flashlight. I *earned* it. Do *you* have a flashlight? I do. Know what *I* am? A survivor!

And I *will* mount that black stairwell at the Carter, all 21 floors of it, all 21 landings and 42 flights of stairs. Up through darkness, my path lighted by the strong clear beam of my trusty *Power Plus*.

Back at the Carter, I announce to sleepy-eyed Abdul in the lobby, "Got myself a flashlight!"

He laughs. "You donneed it. Power's back on!"

Hans Christian Andersen used to travel with a coil of rope to lower himself out of hotel room windows in case of fire. In future, I intend to travel always with my beautiful *Power Plus* flashlight. In my carry-on.

New Jersey transit is running again, too. Within a few hours I am at Fairleigh Dickinson University in Madison, New Jersey, waiting to hear Charles Simic read his poetry aloud before I fly back out of Newark just before midnight. Madison was one of the few places on the eastern seaboard unaffected by the power failure.

As we wait for Simic to come on, I regale a group of MFA students with the tale of my adventures in the dark. The most remarkable part of it all seems to me the terror, the paranoia I experienced on that dark stairway this morning, and I cannot resist telling about it, trying it out to see if these young people will find me strange for having been so afraid. As I tell about my fear, about the pictures in my

mind of faceless strangers with knives lurking on the landings, one of the students speaks up.

It so happens that one of the students in the group is blind. I know he is blind, but somehow, incredibly, I do not make the connection between his blindness and my story, until he cuts in softly, saying, "Well, Tom, now you know how I feel just about every minute of every day of my life. Never knowing for sure who might be there."

Walter Cummins introduces Charles Simic who steps up and starts out with an anecdote describing how after a reading once, someone came up to him and said something like, *Those poems are great because I can hear they all really happened to you.*

And Simic says, "I thought to myself, *I love this guy.*"

The Bridge
Back to Queens

QUEENS WAS AND WILL ALWAYS BE my first home: Jackson Heights, Elmhurst. Here I was born, went to school, learned to swim, discovered books, girls, drink, yearned for distant shores. Here I lived with my sister, brothers, mother, father. Everywhere were aunts, uncles, cousins, neighbors, friends, acquaintances, shop owners we knew by name and their families and employees... I couldn't walk down the street without stopping to say hello to a dozen people. Here, on the next neighbor's lawn one summer day when I was five, I watched with amazement a stray cat stretch out while a tiny wet kitten appeared like true magic from an opening in her body. Here we four boys played on the street with all the other neighbor kids and were proud to see my father come striding heartily home from the bank, a smiling strong-faced man in suit and tie and topcoat, tipping the brim of his fedora to the ladies. And here death first taught its irrevocable cold truth; home from Rockaway Beach one late summer afternoon I found the house empty, windows open, curtains drifting on the breeze, blood spattered all over the living room carpet and a note from my mother: "Dear Boys. We have taken your father to Elmhurst General..."

Originally peopled by peaceful, agricultural Algonquians—Matinecock, Jameco and Reckowacky tribes, Queens was settled by the Dutch in the 1630s, by the English

in the 1640s, established as a county in 1683, incorporated into Greater New York in 1898 and connected to the parent island of Manhattan in 1909 by the Queensborough (59th Street) Bridge. Queens county houses some two million people, a good fourth of the population of New York City, but was long considered nothing, nowhere, temporary quarters, an embarrassment to come from, the desert landscape Fitzgerald's characters motored through from East Egg on their way to Manhattan.

Queens is New York City, too; there are five boroughs—Manhattan, Brooklyn, Queens, the Bronx, Staten Island. Rodgers & Hart forgot Queens in 1925 when they wrote, "I'll Take Manhattan." We noticed the omission. When I was growing up here we gazed across the river to Manhattan and called it "The City."

Here was my home. But it is no longer mine. Gone. Where? *Ubi sunt.* Precisely half my sixty years has been spent in Europe, half in the US, mostly in New York, mostly in Queens. Now when I come back to visit, I stay in Manhattan. Today, however, is set aside for a return.

Beneath the river the E train rides, tons of East River water above my head, as we glide in air-conditioned comfort from Manhattan to the first stop in Queens: 23rd Street and Ely Avenue in Long Island City. For years this was a neglected undesirable factory area, and now is but a toss from the MoMAQNS—the Museum of Modern Art in the provinces.

Today, on 33rd Street and Queens Boulevard, the MoMA offerings feature Andy Warhol, and the factory that once baked Silvercup Bread—original American white—in Long Island City is now a film studio, still with the big Silvercup neon sign in place. I still can smell the aroma of that bread that wafted through the cars of the elevated train. But my destination today is not the MoMAQNS or a film studio. I am revisiting the place where I was born, grew up, returned to repeatedly over the first 30 years of my life after the army, after running off again and again to Route 66, to the west coast, thumbing through the country in search of what I still had not realized was within myself. You can leave your shore but not your soul behind, some Latin poet once said. Or as the Danes put it, "The sprite travels with you." Nonetheless, the process of making this discovery includes flight and return to finally know the place, regardless of where you land.

Now I'm back, I think, as I climb out of the belly of the subway beast through Jackson Heights's Victor Moore Arcade—featured in Alfred Hitchcock's 1956 film, *The Wrong Man*, where Henry Fonda plays a Jackson Heights man wrongly accused of murder who spends eight years in jail before the real killer turns up, during which time his wife loses her mind; a true case in which my father served as grand jury foreman, forever after regretful that they had voted to indict even if he did follow his conscience. On another Grand Jury murder case once, Queens DA Frank O'Connor warned my father, "Let that man go and he'll go out and kill somebody

else." But the Grand Jury thought the man was innocent. They let him go, and he went out and killed again. I remember my father telling me these things, remember the set of his broad jaw, the light in his brown eyes; he offered no explanation or excuse for these failures of human intercourse, these errors, only pointed at them and set his jaw and gave me that look he sometimes had on his face when he said, "You're a bright kid. You figure it out."

I rise from the subway into the light on Roosevelt Avenue and 74th Street to a scene straight out of Asia. Nothing is at it was. The shopfront signs are in Korean. The old Earle movie house, formerly the only place in town screening European films (Fellini, Bergman, Mai Zetterling), now specializes in Bollywood. Down the street from the Earle was a little dead-end known popularly—perhaps simply because of the proximity to an "art cinema"—as "Fag Alley" for it was rumored to be a meeting place of homosexuals. The word on the Earle was don't drop the soap in the men's room and don't use the urinals, stick to the stalls; fags were big on that artsy European stuff.

The Long Island City Savings Bank on 74th Street, a branch my father opened in the 1950s, offering a free toaster to anyone who started a savings account for at least $5.00 at 3-1/4 % quarterly-compounded interest, is gone, replaced by a branch of the Astoria Federal managed by people of Indian descent. On 37th Avenue (formerly known as Polk Avenue, for the 11th president of the US), wares are sold from side-

walk stalls by men in robes and turbans. Along 82nd Street, where my Irish aunt had her law offices, were once button shops, furniture stores, Florsheim and Flagg Brothers and Thom McCann shoe shops, Woolworth's and Kresge's 5 & 10-cent stores staring across the street at one another, complete with soda fountain and lunch counter (chicken salad sandwiches and black-and-white sodas!), Jewish and German delis, four good Eyetalian restaurants, movie houses and many Irish restaurants and bars. Now the street's main feature is a spate of shops selling religious statues and artifacts of superstition—aerosol cans whose spray promises to ward off the evil eye, attract good fortune, arouse desire in love objects, hasten triumph over one's enemies.

I walk Roosevelt beneath the elevated train—the "El"—toward my first home, in Elmhurst, at 40-37 Gleane Street. Most everything is gone, transformed, rebuilt, broken down and rebuilt again. The Elmar Lanes bowling alley is now El Capitolio Taberna. The Drum Bar is El Tambora. Baxter Avenue and 83rd Street is now subtitled *Manuel De Dios Unanue St.* The little shoemaker shop where I worked for a buck an hour every afternoon and most Saturdays through high school, waxing the edges of tips and soles and heels, sanding raw leather, slapping on dye, air heady with the smell of glue and leather and polish—gone.

The proprietor was Anthony A. Antoniou of Crete, a resident of neighboring Astoria which boasts or boasted the largest enclave of Greeks in America. Tony was a handsome,

friendly, mild-tempered boss with a delightful accent. I lived for the days he would ask me to fetch the rubber gloves he wore for dying leather—"wobba golves" he called them. The only time I ever heard him raise his voice was when a man came in and banged a pair of crap-encrusted cowboy boots onto the counter to be cleaned. Tony had been a Screaming Eagle paratrooper during World War II and still sky-dived on weekends. A repairman working on Tony's stitcher once saw the 101st Airborne chevron beside the cash register and threw his arms around Tony, crying, "Were you at Rurh in March '45? You liberated us!" Wiping his eyes, he refused to let Tony pay for the repair.

Working for Tony, I had frequent breaks with free coffee and French crullers, and he insisted I sit down with my coffee while he worked at his last. "Take care your legs." He was vastly amused to watch me blush whenever a beautiful woman entered the shop. Hell, I was a teenager, reared in puritan Roman Catholicism, *every* woman was beautiful: taking the pumps and heels and sandals where their feet had been was a near religious experience—sometimes still warm from their delicate trotters as they sat barefoot in the little booth to wait. Tony would be how old now? Gone, I suppose, as is his shop, replaced by a Colombian bakery. All the little shops are gone, changed hands and faces and accents. Here and there, a familiar one remains, though looking smaller and shabbier. Still there is Fortune Cleaners, which I wrote about in a short story published in 1989 in *New Letters* maga-

zine, "What Does God Care about Your Dignity, Victor Travesti?"

The street across from Tony's used to be a row of small businesses: Steve's diner; the Eldorado Bar & Grill, where my brother and I sometimes were allowed to play the electric shuffleboard and drink glasses of gingerale stuffed with maraschino cherries while my father threw back shots of rye at the bar beneath a painting of goatmen chasing naked women; Tommy and Grace Rivera's Latin grocery shop (formerly Heisse's German dellie); around the corner the little ramshackle *Star* office where the boys who delivered the *Long Island Star* each afternoon gathered to fold their papers, play cards, and smoke cigarettes. *I still can hear the papers thump on lost porches.*

On that corner was the *pièce de résistance*: The Hampton Luncheonette with its rock and roll jukebox, five plays for a quarter, proprietor Fat Sid, where for one green dollar you could get a hamburger, fries, a malted shake, a pack of butts, and a silver dime and copper pennies in change. (The US had gone from the gold standard years before and was then on the silver standard; dollars were called "silver certificates" redeemable in silver on demand; precious metals were the foundation of it all.)

That whole block burned down in 1960, a great fire that illuminated the winter sky all night. We stood in the crowd, flames leaping up into the cold black sky, and watched a hunk of our town disappear—even worse later to see it re-

placed by a massive pink-brick apartment building. Teenagers would never again gather after school in the booths of the Hampton or do the lindy hop there to Little Richard or Fats Domino or a slow grind to the Penguins' "Earth Angel."

The opposite corner of Hampton and Baxter once housed the classiest joint around, originally The Hollywood (with potted palm décor), later The Outside Inn (with a jazz trio and draft beer for the then exclusive sum of 25 cents per eight-ounce glass—it was 15 cents most places—Ward's, Kilkenny's, Murphy's, Ryan's, Nellie Keogh's Rose of Tralee, Walter P. Shea's, Powers and Healey's, a mere dime at the Bridge Inn). There my older brothers were greeted by name by the bartenders, sat at the oval bar in dim light, immersed in jazz, flirted and laughed with girls for whom I ate my heart out. Now the building is occupied by a sprawling, gaudy, blue-and-red, round-the-clock laundromat. What is wrong with these people? Have they no need for bars! What is a clean shirt without a little fortification for the spirit?

Further along Baxter is the looming complex of Elmhurst General Hospital where back in the '50s was a big open lot called Gray's Field and there boys in real uniforms with regulations mits and bats and hardballs played baseball in the summer afternoons to an audience of parents and siblings seated on fallen trees and plank-and-brick bleachers. And every summer for a week or two, the carnival would arrive; tents were pitched, rides set up (the whip, a carousel), games of chance, the freak show. The carnies would con us into

fetching buckets of water for them from the Esso Station and pay us for our labor with the horse laugh. We didn't care. With any luck we would get a glimpse of the Great Leontini with his three legs, four feet and sixteen toes. Or of one of the very sexy women who moved about smoking cigarettes, in tight slacks, leopard-print kerchiefs, painted faces and cool, mascara'd eyes. Gone now. All of that.

At least the El is still here, rumbling some 30 feet above my head, mounted on institutional-green steel girders. As it has done at regular intervals every day since 1916, it rises out of the mouth of the East River tunnel and crawls, screaming, up the track, steel against steel, to Queensborough Plaza, at that time the most complicated elevated station in the country, accommodating four different lines on two levels. Today, it continues above Roosevelt Avenue through Astoria (home of Tony the shoemaker and, once, of Tony Bennett, too), Sunnyside (where Bix Beiderbecke once lived, home of Archie Bunker and Vietnam-War-Medal-of-Honor-winner O'Mally, about whom Jimmy Breslin wrote a series in the Sunday *Tribune* magazine section; where a playground is named after another recipient of the Medal of Honor, LCpl Thomas Noonan, killed in action in 1969 in Vietnam, whom I remember from Beach 108 at Rockaway during the summer of '65 when he had the nickname "Tommy Tarzan"), Woodside, Jackson Heights, Elmhurst, Corona (home of Louis Armstrong where Cannonball Adderly, Dizzy Gillespie and Clark Terry all lived at some time), past the old Flushing

Meadows site of two World's Fairs (1939-40 and 1964-65), where I used to fish in the swamp for guppies and, with my friend Billy E, at the age of eight smoked Lucky Strike cigarettes stolen from his mother's purse. Past Shea Stadium, the train crawls on to Main Street, Flushing, last stop: Everybody off. There, with my shoemaker bucks in 1960, at the age of sixteen, I bought myself a thirty-dollar three-piece suit of olive green, red paisley lining, natty brass buttons, and felt like half a million with my shiny new brushed-chrome Zippo, gold-plated spring-top cigaratte box full of non-filter Pall Malls (*"In hoc signo vinces per aspera ad astra,"* it said on the packet, translating which was about the only practical use I ever had for my high school Latin, to impress friends: "In this sign you will conquer, through adversity toward the stars"; where now is splayed death warnings).

My father was pleased I'd used my earnings to buy dress clothes, but took one look at me the first time I wore them and said gently, "Every man buys a green suit once in his life." I was not phased. I was off sporting in those "boss threads" in a Checker Cab to collect the lovely Anne R from Forest Hills, tucked into my breast pocket two tickets to the Wintergarden for *West Side Story*, Leonard Bernstein himself conducting. After the show we dined at Mama Leone's. I was excited. Not only because Anne and I had recently progressed to full frontal standing embraces on her shadowy porch, but by the show itself. I had never been to a Broadway play before. I had no idea there would be a whole live

orchestra, a modern Romeo & Juliet with people dancing and knife-fighting on stage, flinging the "f" word at one another. As our yellow cab carried us back over the bridge to Queens, I popped open my cigarette case, offered the lovely 14-year-old auburn-haired Anne a Pall Mall, and asked if she would care to join me for *My Fair Lady* the following weekend.

"No need to overdo it," she said.

Still standing today is the house where I was born—a narrow, shingle-and-stucco seven-roomer tucked into the middle of the first block of Gleane Street, the tiny neat lawn behind the wrought iron fence my mother had erected in 1964, after my father's untimely death. When I was a boy, the house was beige, then forest green. Now it is canary yellow, home to a Korean family, the once open driveway locked behind a ten-foot iron-barred gate. My father bought it in 1940 for $10,000; I suppose the current value is a good 50 or more times that.

I stand on the opposite pavement, gazing up and down the street of one-family houses. I used to know the people in every one of them—the Groughtons, Dalys, Greenbergs, Goases, Wolfsons, Morrises, Kellehers, Marrotts, Savareses, O'Connells, Hoffmans, Busches, Fowlers, MacGowans, Minnexes, O'Hares, Dr. Connell the allergist... A family from India moved in back then with a little boy whose amazement at the plentitude of food amazed us; he showed us excitedly around his kitchen, opening cabinets and refrigerator, exclaiming, "Look! Food! Food!" My eyes flick from house to

house, and all the faces of the families rise to the screen of memory. There were a good 20 kids on the block. The best street in town for roller-skating. Traffic was slow. We played stickball and punchball in the road. "Red Rover" from one side of the street to the other. "Giant Step" up the drive-ways. "Statue"—delicious tension of having to jolt stockstill when the leader hollered, "Freeze!" and everyone became a statue, all frozen in bizarre postures. With a stick of white chalk we drew a circle in the middle of the smooth black tar and sectioned it off like a pie, labeling each slice with the name of a different European country, each country assigned to one of us, and played "War" with a pink rubber Spauldeen ball that I can still smell, can still feel in my palm whenever I picture it: "I declare war on...*Germany!*" Slam the ball into the German sector and run; the person designated Germany then had to get the ball and hit you with it before he himself could declare war on someone.

There were people in the neighborhood we knew only by name who traversed our territory. A young man in suit and tie named Edward Faster who came past at a rapid clip each evening on his way home from work; he had to pass through a gauntlet of kids shouting, "Faster! Faster! Faster!" and his gait accelerated with each shout to carry him past the tor-ment. Another person I never even saw was named Wolf-gang. Someone would shout "Wolfgang's coming!" and we'd run and dive for cover. Heart beating wildly, waiting for the all clear, I'd hide in a basement or backyard, convinced that

there was imminent danger of attack from "The Wolf Gang," which I pictured as half a dozen hairy boys with fangs.

We acted out movies, too: *King Solomon's Mines, Wolfman, Frankenstein Meets Wolfman, Abbot & Costello Meet Frankenstein, The Thing, The Day the Earth Stood Still, Singing in the Rain.* I was always allowed to play "The Thing," because I died well, and nobody ever questioned the fact that a little boy nicknamed Butch always clamored to get the part of Debbie Reynolds (which he pronounced "Deb-*bye* Ren-*olds*), wrapping his jacket around him like a skirt. And alongside our house and the houses of others, the whole army of us, each armed with cap pistol or broken BB rifle or gun-like stick played "Battle It Out in the Alley," firing imaginary bullets of joy at one another, killing with glee, dying with theatrical ecstasy.

Boxing matches were organized in the backyard of Pinky, an English boy up the street, kids paired off by age and size to duke it out wearing somebody's toy boxing gloves. I was the shrimp and had to fight a girl, Joanne Teofilio, the only one near my size; apparently it was assumed that her two years of seniority would be counterbalanced by my natural masculine strength. She was on me like gangbusters from the sound of the bell (Pinky's side door buzzer, sounded through his open back window). She was faster and stronger and bigger, and she slapped instead of punched. Still I can feel the burning tears of shame when the referee, Eddie Hoffman, aka "Moon," held up her trium-

phant hand at the unanimous decision of the judges. Beaten by a girl. A *girl!* Joanne also occasionally granted me the sacred privilege of seeing hers in return for seeing mine, a price I was pleased to pay.

We were all terrified of Joanne's mother, who suffered from acromegaly, poor poor woman, and had a grotesquely elongated chin and nose. I recall once Mrs. Teofilio threw a birthday party for Joanne, and our parents informed us we were to *accept* the invitation. And as we sat in their little living room over Kool-Aid and cupcakes, Mrs. Teofilio put on a record, "The Anniversary Waltz," and she gracefully, dreamily waltzed herself around the carpet, eyes closed, acromegalic face smiling softly with the joy she saw behind her eyelids, singing quietly along:

Oh!
How we danced
On the night
We were wed…

Their apartment was above the hardware store owned by a man we called Hitler because of his tiny black moustache and glaring eyes and the Hitlerian ranting fury with which he would chase us when we scooped up handfuls of black humus from the barrel outside his shop to fling at one another. We'd yell back "Heil Hitler! Heil Hitler!" It never occurred to us that the poor man was Jewish; nor were we yet aware of The Holocaust. I had my first glimpse of that on TV in 1960 when I was 16, documentary footage that showed trac-

tors rolling mounds of emaciated naked corpses into pits. I don't recall anyone at home commenting on that. It was as though we took in the horror and buried it deep in the darkness within. Similarly we had also somehow managed to keep submerged beneath our consciousness the obvious facts of American racism and sexism. At home, we were sharply admonished if we used the ugly word *nigger* and my father always responded to any slur against black people by saying, "Think of all the good Negroes who are just trying to take care of their families like everybody else." But we never saw the conditions under which "Negroes" lived in nearby neighborhoods we never had occasion to visit and only vaguely knew were there; we rarely saw any "Negroes" at all and had little, if any, awareness of the racially, or sexually, based socio-economic inequities of our society—that is not until it began to leak out through the television set.

My first exposure to overt racial discrimination was the summer I was 17, and my father got me a job as an internal messenger for a stock brokerage on Wall Street. One of my duties was to sit in for the receptionist on her lunch hour, and I was briefed that if any "colored people" came asking for the personnel department I should tell them there were no openings. My surprise and indignation only underscored the lack of social awareness surrounding me and the impoverishment of my own powers of enquiry and observation. It occurred to me recently that by extrapolation, we would have been among the "good Germans" who knew nothing

about the extermination camps, although we might have known, should have known, are perhaps responsible and culpable for not having known. We knew. We just didn't want to look that knowledge in the face.

As for sexual discrimination, we boys thought it great fun to chase girls with snowballs and worms and took it for granted they enjoyed it, too; nor did it occur to us that it was unfair my mother had to give up teaching and spent so much time in the kitchen. My most prominent memory of my mother is of her standing at the sink or at the stove with her back to the rest of us as we sat and chatted around the kitchen table; she performed this work without audible complaint, though we might have noticed she was not overjoyed at her role and was unhappy that she had to quit teaching to stay home and take care of the kids after number three was born. Our lives were free of so many troubling thoughts then. It would be interesting to sit down now and contemplate what similar things we fail to notice today.

There was a tree growing from a strip of earth at the curb in front of every house on Gleane Street then. Gone now, every one of them, and encroaching from each end of the street, a lengthening line of three-family row houses, all identical, slowly eating away the variety of little one-families of the past. I stand on the cracked pavement peering at the ground floor of my old home, through the front windows behind which my father, vice president of a five-branch bank by day, sat most nights at his mahogany desk writing poems,

only two of which were ever published; one of them in *The New York Times*—a historical sonnet about this neighborhood, titled "Village of Newtown," the original, 1652 name of Elmhurst:

> *On this historic spot where I now stand,*
> *The Mespat tribesmen once stalked stealthily,*
> *And stolid Dutchmen plowed unbroken land*
> *On grants bestowed on them by royal decree.*
> *Bedraggled lines of Continentals stood,*
> *Repelling hoards of scarlet grenadiers,*
> *And little children played about the wood.*
>
> *This was the scene of triumph and of tears.*
> *Gone are the tribesmen and the redcoat now,*
> *Oblivious to parry and to thrust*
> *And underneath the land they used to plow,*
> *The settlers lie buried in the dust.*
> *And all is changed, even the old town's name –*
> *Only the constant ground remains the same.*

Ubi sunt. He had that love of the history of the place, used to take us walking down to Broadway to look at the old wooden church of St. James there, built in the early 1700s, at the foot-square cube of granite alongside the roadway on Britton Avenue, a stepping stone from the coach days. And the old house in a lot on Broadway for some reason known as Lee's Lot which had been the country place of Clement Clarke Moore. It was, in fact, we were convinced, the very

place where he wrote "'Twas the Night Before Christmas," despite the legend that he had composed it on Christmas eve, 1822, on a sleigh ride home from Greenwich Village with his family. In the late 1950s that lot was raked away, Moore's little country house with it, and paved over with concrete for a playground. Only a plaque attested to Moore's history there. Today, my father would be perplexed to learn, Moore's authorship of the poem has been contested by Professor Don Foster of Vassar (irony of ironies, Vassar having been the college of choice for the women of Dad's family) whose evidence indicates it was actually written by Major Henry Livingston, Jr. (1748-1828), and published anonymously. Moore, a professor of classics at the General Theological Seminary in New York City and author of the ponderous two-volume *Compendius Lexicon of the Hebrew Language*, is said to have laid false claim to authorship of that famous Christmas verse.

It comforts me that my father did not have to know that, as I stand looking across to the little house he so loved on the little street he so loved and wrote poems about. I think I could close my eyes and raise vividly into memory every split in the floorboards of the house, the interior of every crawl-in closet of my childhood, the two small stained-glass windows picturing stylized fruit bowls high up on the living room and dining room walls, the many volumes in the four mahogany, glass-doored bookcases of the living room, the pattern of the carpet beneath the dining table which pro-

vided roadways for my toy cars and the table-legs that simulated forests for my toy soldiers, the intricate geography of the basement with its frightening machines—a water-cooler that suggested a plump white extraterrestrial insect on four long spindly legs, the oil-burner whose mouth could be opened to reveal secret fire raging at the heart of the house, and the wooden skid which could be pried away from the wall, opening onto a black hole—an earthen-floored crawl-space. What mysteries buried in that dirt? The father of the boy next store had once dug up an old double-barreled flint-lock pistol from the crawl-space beneath *their* porch! Had there been pirates here?! Only years later did I realize that gun must have been a plant to liven up our imaginations.

Memories flood up! Nineteen-fifties summer nights with my brothers and sister huddled together in the black-and-white flickering glow of Charlie Chan or Sam Spade on the Million Dollar Movie and the Late Late Show, Jimmy Cagney with a tommy gun, Richard Widmark chuckling with mean glee as he shoved an old lady in a wheelchair down a tenement staircase. The feel of the bathtub against my knees as my brother and I knelt to peer through a slit of the open window to watch Mona, the next door lodger, strip naked before her open window. Years later, I would learn, my father also copped the occasional peek himself, a fact disclosed to my oldest brother next day when he would comment at breakfast, "Lovely moon last night," even if it had been overcast.

Down below in the basement, in 1959, I learned the unreality achieved by guzzling four cans of Rheingold while Big Mama Thornton sang "Hound Dog" on my portable Webcor—and paid the toll to ecstasy with nausea, stooped over the seatless bowl in the back W.C., my miserable face reflected, groaning, in the stained porcelain pool.

Upstairs in my tiny second-floor bedroom I discovered the secret world within: Dostoevski, Steinbeck, Joyce, Mansfield, Camus, Gide, my closest friends those days when I thought myself the only heartsick lonely kid in the world. Here where life was still and sad and happy as the old scratched furniture in the shadowy rooms, the dusky blue curtains, the frightening framed portrait photograph of Pope Pius XII peering in judgment from behind glittering spectacles, from atop the landing of the creaky wooden staircase, just beneath the carpeted hallway of closed bedroom doors. Behind my door some manner of revolution had begun. One of the Karamazov brothers was making pronouncements about the non-existence of God or punishment, and all his saintly possessed passionate Petersburg madmen were breathing life into ideas I barely dared consider.

In the kitchen, at the old metal-topped table, the seven of us would linger some summer evenings after pot roast and potatoes or corned beef and cabbage to listen to my father read his poems aloud or the poems of Edna St. Vincent Millay, John G. Neihardt, Leigh Hunt, A. E. Housman, Emily Dickinson, James Stephens, Robert W. Service... I still can

hear his voice, rough with the smoke of nonfilter Camels and whiskey, his warm sharp eye making contact to emphasize a line: "One of you men is a hound from hell. And that man is Dan McGrew!"

Up the street, the big brick box of Public School 89, which my father attended as a boy in the 1910s, still looms on Britton Avenue, but gone is the schoolyard where on summer days and nights later generations sat and shot the bull on the ledges of the tall broad windows, shot baskets beneath netless hoops, shot craps in hidden brick alcoves, or played three-card monte and five-card stud for nickels and dimes, drank beer from the can, two triangular openings punched into the tin top by the "churchkeys" we all carried on our keyrings in those pre-poptop, pre-twist-off days. In the evening shadows of the eternal summer, at the corners of the chainlink fence, there was always a couple necking where in the afternoons we played stickball on the concrete field or handball and fast pitch-'em in against the brick wall of the cafeteria, the spin of the bounce always a surprise on the crackled cement court. A jerry-built annex has obliterated the site and with it the gathering place of generations of youngsters, a concrete, graveled garden of innocent sin.

On the corner across Britton Avenue from PS 89, what used to be Blake & Hosey's—a run-down candy store with a license to serve beer—is now a run-down laundromat. Gone all the locals who sat and gossiped over a glass of beer, changing infant's diapers on the bar. Gone Rich's vest-

pocket grocery shop where I used to buy tuna heroes for a quarter. Gone. And just up Hampton Street from there lived the Sklar brothers, "tough Jews" they were called, as though the phrase was an oxymoron, Herbie on his Harley and Morty, it was rumored, on a wilder horse. Years later, I would meet Morty when he was editor/publisher of a literary magazine, *The Spirit That Moves Us*, in Iowa City. Still later he would publish one of my stories in an anthology of Queens writers he edited and published, *Patchwork of Dreams: Voices from the Heart of the New America* (eds. Morty Sklar and Joseph Barbato, The Spirit that Moves Us Press, 1996). My own story in the collection was titled "Bliss Street," from the street of that name two miles west in Sunnyside, in the shadows of the El tracks, where Bix Beiderbecke once lived, the original *Young Man with a Horn*, dead at the age of 28 in 1931.

Goodbye, goodbye.

I ride the El from 82nd Street back towards Manhattan, but when the train slides in to the Queensborough Plaza station, I get off, climb down the staircase to the road-and-traffic snarled Plaza where my father worked for thirty-eight years behind the polished brass doors of what is now Astoria Federal Savings Bank. This building had been taken over in 1920 as the headquarters of the Long Island City Savings Bank, established 1870. My father started working there in 1925, when he was nineteen, when his own father died, skipping college to earn a living while his older sister went to

Vassar. Here behind these tall polished doors he spent the bulk of his adult life. I still have the engraved 18-karat gold Hamilton watch with which he was presented in 1950 for a quarter-century's service. Fourteen years later I would come home from an afternoon at the beach to find the living room of our home spattered with blood. My mother would tell me later that he had suddenly spouted blood like a fountain. I hurried over to Elmhurst Hospital where he was dying of a sudden internal bleeding whose source the doctors could not locate or close. Three days later he was dead. In that hospital complex that rose from the field where he used to take me to the carnival a decade before, where we used to watch base-ball games. Fifty-eight years old. No age at all. Dead of drink and broken dreams. He so wanted to be a poet. He was a poet.

At the foot of the bridge that spans the East River from here to Manhattan, I decide to walk across, and this makes me think of John Cheever, of Susan Cheever, of the hub of coincidental crossing-points that is a life:

In April 1998 I was in Montevideo, Uruguay, for a conference. I cannot remember much about the trip other than a close encounter with an angry tarantula, a surly gaucho who scowled at me from his lofty saddle when I waved to him out on the pampas. But I do remember that in the little hotel newspaper shop, among the paltry offerings of John Grisham, Tom Clancy, Danielle Steele, and Harold Robbins, was a sun-bleached hardback copy of Susan Cheever's *Home*

Before Dark. A biographical memoir about her father, John Cheever (1912-82), it was published fourteen years before, in 1984, when I was an MFA student, a book I'd wanted to read but which, living in Denmark, I never happened upon in a bookshop. Finding it like that in Montevideo was irresistible. Like many readers and writers of my generation, I was greatly taken by Cheever's fiction, ever since the day in 1963 when, stationed at Fort Benjamin Harrison army base in Indianapolis awaiting orders, I found a copy of Cheever's *Some People, Places & Things That Will Not Appear in My Next Novel*, left behind in the footlocker of a buddy who'd just shipped out to Vietnam. Cheever was a writer who could teach one "to respond to the inestimable greatness of the race, the harsh surface beauty of life...," who could put one's finger "on the obdurate truths before which fear and horror are powerless."

I wanted to read what Susan Cheever had to say about her father, and I did. It was a sad story that made no excuses but which also helped me see and empathize with the pain Cheever endured to produce the fine music of his fiction. It was also a story that rippled with light amidst the darkness. In Chapter Eight, she tells about the time her family lived "in a brick apartment building at 400 East Fifty-ninth Street...just across the street from the sooty, noisy rumble of the Queensboro Bridge." Susan Cheever tells how her father used to put on "his one good suit each morning and his grey felt hat and ride down in the elevator with the other men on

their way to the office." But Cheever would continue to the basement where he would doff his hat, remove and hang his suit so it didn't get wrinkled, and write all morning in his boxer shorts in the family's windowless storage room. Some afternoons when she came home from school, the two of them would walk across the Bridge toward Queens and stand in the middle—where I am standing now—to peer down at the flowing, swirling river below them.

And I wanted to write to Susan Cheever to tell her how at just about the same time she and her father walked across the Bridge, my own father who wrote poetry at night was during the day Vice President of the headquarters of a small chain of banks at the other end of that Bridge. I wanted to tell her how in the early 1950s, he took me and my brother on the final tour of the last trolley car across that Bridge. He told us that one day we would remember there used to be a trolley car across the bridge and that we were there on the last crossing. He told us it was important to remember things.

Standing here now, I think of all the times I have crossed this bridge, how I loved it in the way Simon & Garfunkel, also Queens boys, did when they sang "Feelin' Groovy (The 59th Street Bridge Song)," and how, like Susan Cheever's father, I developed a fear of driving over it. In my case, it was a fear that rippled up from the feel of my tires sliding over the metal grating of the upper ramp. That slick metal seemed always to threaten to throw me into a skid that would pitch

the car through the railings into a plumb drop to the treacherous currents of the river I loved. I watch it now, flowing down toward the narrow foot of the island, and I want to tell Susan Cheever how I admire the love and honor she showed her father, and shared with the rest of us who loved him for his work, in taking on what could only have been the difficult work of writing that book.

How I wish I could do the same for my father.

Land Where
My Fathers Wrote

THE NATIVES CALL IT N'YAWK. One impossible syllable. Or two: N'Yawk N'Yawk. The city where my father wrote. With little success. I tried, too, for fifteen years, about a fourth of my life, on the same Remington manual typewriter, later an IBM Selectric, with even less success. At least Dad published two poems—one in *The New York Times*. I had to leave the city, get out of the country, to write anything worth publishing. Back to the old world.

These days, probably more struggling writers, and some successful ones, hole up in Brooklyn where I went to high school, riding 45 minutes every morning and afternoon on the GG subway from Queens, hunched in the rattling seat over *Crime and Punishment, The Brothers Karamazov, The House of the Dead, The Insulted and the Injured...*

In those days it took a 15-year-old chick from Poughkeepsie to lure me across the river to the Village. What Dylan a year later would ironically pronounce "Green-wich Village" in "Talkin' New York Blues." I was sixteen and it was 1960, and we went into the Café Wha?, which, lacking a liquor license, served ice cream sodas, so minors could come in and hear, that winter night, the black Beat poet Ted Joans slapping his palms on the table as if it were a bongo drum, and chanting a lyric that went something like:

Sex:

Good sex

Bad sex

Backseat sex

Backrow sex

Kitchen sex

Bedroom sex

Sofa sex

Outdoor sex

Drunken sex

Ice cream sex...

Ted Joans knew what we were thinking about. The chick from Poughkeepsie was groovin', and I—a Catholic-high junior—thought the whole scene was weird and funny and bogus and cool. I wore my dark-rimmed Buddy-Holly style shades and a black beret and turtleneck and must have looked like a classic jerk to the incredible, long-haired, long-limbed, beatnik waitresses, their black leotards outlining ecstasy for me.

Back then it was Manhattan that called to young writers from around the country and across the rivers, when it was still possible to find a cheap garret and hunker down to write through freezing winters and steaming summers.

Today, in the new millennium, it is a hot town, summer in the city, and the New York August heat enough to drive a man mad. Woman, too. Air-conditioners churn full force, dripping on your head as you pass beneath them, but they have yet to concoct an air-conditioner that can cool the

streets. Out here you work up a constant thirst with plenty of cool places to quench it, and I am back to wade the naked, steaming streets in shorts, armless tee shirt plastered to my sweaty back, seeking out places where writers have lived or drunk, as good a structure as any for a one-day visit here, though an impossibly ambitious one. It would no doubt be easier to draft a list of the writers, artists and musicians who *didn't* live here at some time or another than those who did.

How many readers, for example, know that Antoine de Saint Exupéry (1900-44) wrote *The Little Prince* here, on the 23rd floor of 240 Central Park South at Columbus Circle, where he lived during the German occupation of France in World War II? He died on a military reconnaissance flight over France in July 1944. It exasperates me that I only have just learned that he lived there, just across from where I worked for several years in the 1960s, on the 12th floor of the now-demolished Coliseum Office Building at 10 Columbus Circle, at the time I first read *The Little Prince.* And what, you may ask, would it have mattered if I had known? Perhaps nothing. Perhaps a good deal. Is it of value to cultivate our awareness of great things that have been accomplished just across the street from where we toil in drudgery? I think it is. I want to know these things. I want to know the geography of it, the housing.

In order to make my search for such knowledge nominally superable, I focus mostly on the Village, but even that is too much. Plot the poetic production of Allen Ginsberg

against his residences, for example, and you will find that in the East Village alone he lived in half a dozen apartments between 1952 and 1997. For fellow-obsessives who might want the list, here it is:

206 East 7th Street (1952-53)

170 East 2nd Street (1958-61)

704 East 5th Street (1964-65)

408 East 10th Street (1965-75)

437 East 12th Street (1975-96)

404 East 14th Street (1996-97).

Ginsberg, too, unbeknownst to me, lived around the corner from where I lived in 1966, at 184 East 3rd Street, between Avenues A and B.

Now I wade through 95 degree heat and humidity to revisit my old digs and to acquaint myself with his. On the way, I pass the Hell's Angels NYC headquarters, which has been considerably spruced up since they were my neighbors 3½ decades ago. Their building displays a flag-bearing patriotic poster: *Support the troops...Love It or Leave It*—which, in 2007, suggests the mind-set of our current leaders' policies and of the authors of the document entitled "Uniting and Strengthening America by Providing Appropriate Tools Required to Intercept and Obstruct Terrorism Act of 2001," known by its acronym, "The USA Patriot Act." Who would dare vote against an Act called Patriot in the bruised and bleeding month of October 2001? Practically nobody did. To bristle against the forced bridling with the word "Patriot" in

2001 and 2002—or to vote in October 2002 against the invasion of Iraq for a trumped-up alarm about weapons of mass destruction—was akin to expressing skepticism about the House Un-American Activities Committee in the late 1940s and early 1950s.

In those days, the major fears were of "the international communist conspiracy" and sexual "preversions" and the danger of getting caught in a sex-trap, blackmailed into becoming a traitor to your country. As an 18-year-old soldier in 1962 recruited to work in the White House, I submitted to a top-secret security clearance process that included a polygraph interview in which a middle-aged colonel asked me, in dead earnest, whether I'd ever had normal sexual relations with a woman, abnormal sexual relations with a woman, sexual relations with a man, sexual relations with an animal, or belonged to any one of the organizations on a lengthy list that started with the Abraham Lincoln Brigade, all tainted red. You had to hand it to those commies, naming their organizations after Abraham Lincoln!

No doubt my experience with that clearance process inspired me in the mid-1960s to gravitate toward the liberation I saw in Village publications entitled *Screw* and *Horseshit* and *The East Village Other*.

Understandably, my own ex-digs at 184 East 3rd Street between Avenues A and B retain no mark of my stay there in 1966-67, during which I wasted my time *inhaling*, although one night, I commissioned a psychedelic graffiti artist to

adorn the walls of my first floor studio with magic marker murals. The apartment became a curiosity amongst the neighbors; strangers would knock on my door to come in and view the array of naked dayglo popes, uncomplimentary effigies of Lyndon B. Johnson and J. Edgar Hoover and other caricatures, cartoons and obscenities. My departure in February 1967—fleeing west in a buddy's Ford—was at midnight with forfeiture of my $105 deposit.

Now I chat with the superintendent who is out sweeping the walk, a triple XL *God Bless Our Land* T-shirt over his breadbasket. With Russian accent he tells me the rent on the apartment I had is now a thousand a month, ten times the '60s rate. Of course, my salary then, assisting an East Broadway offset printer, was $90 a week without overtime. I walked to work everyday, past the Men's Welfare Shelter and its reek of human degradation. I was twenty-two and had a crush on my supervisor, a 45-year-old red-haired Italian named Claire who threw a party in the office to celebrate her divorce where, a bit tipsy, she told me I reminded her of a priest and asked if I would give her absolution for her sins. I made the sign of the cross on her forehead, even as I contemplated graphically the sins I longed to share with her

The redneck bar across the street, with its nasty little yapping dog named Susie, is gone—as is, south across Avenue B, the once great Slug's at 242 East 3rd Street (between Avenues B and C), just around the corner from where Charlie Parker lived from 1950 to 1954 at 151 Avenue B. Slug's

hosted new jazz (Ornette Coleman, Pharoah Saden, Albert Ayler, The Sun Ra Arkestra) from 1965 to 1972 when it was closed after trumpetist Lee Morgan was shot to death there.

I said my own goodbye to the area in 1971 after my girl-friend's neighbor fired a rifle through her apartment door because her dripping faucet was driving him nuts. He had warned her the day before he would kill her if she didn't fix it. Although she was standing behind the door, she was not hit, but the sight of the bulletholes caused me to lose interest in the area. She and I fled to Queens the next day.

When I had moved to the East Village it seemed a place where classes and races mingled in peace—"Salt 'n' Pepper City," one of my friends called it—but in 1967, a hippie named Groovy and his coffee-heiress girlfriend had their skulls smashed with cinder blocks by two black dudes in con-nection with an amphetamine transaction; the headline in the *East Village Other* said it all: *Groovy is Dead.* And the so-called "Summer of Love" was more than over. I recall omi-nous incidents in Thompkins Square Park—inter alia, a very strange guy who used to shuffle around mouthing a mantric chant of *Ever see a naked white woman? Hangin' by her hair? All covered with blud?*

Murder statistics for the city as a whole climbed steadily from 1963 to a peak in 1990 of 2,245. The figure for 2002, at 587, was the lowest since '63 (though 2001 must have spiked, with the Twin Towers). A recent article in *The New York Times* reported, as if consolingly, that "on average fewer

than two people are murdered in New York City each day."
Nice, for almost everyone.

Since 1972, East 3rd between B and C has been the home
of the Nuyorican Poets Café at 236, founded to give voice to
Puerto Rican poetry but also having hosted poets like Amiri
Baraka, Allen Ginsberg, Gregory Corso and others (their cur-
rent program can be accessed at www.nuyorican.org). As I
come by, the café's façade is being redecorated by two guys
whose English is no better than my Spanish, precluding chit-
chat.

Farther down 3rd is the Kenhelbaba Sculpture Garden,
which advertises an entrance on East 2nd , though I am un-
able to find it. What I do find on 2nd is Ginsberg's pad in the
Croton at 170 East 3rd between A and B, now marked by a
plaque. Amusing to note that the lobby of this residence of
the free-spirited Ginsberg, behind an iron-grilled glass door,
is adorned with a notice sporting an enormous *NO*, forbid-
ding ballplaying, carriages, peddling, sitting in front of the
building, or trespassing.

I have plans for lunch with a Penguin-Putnam editor, so
I take the crosstown journey beneath the anvil of the sun
along the entire river-to-river span of Houston Street (out-of-
towners are cautioned that the street's first syllable is *not*
pronounced like the city in Texas, but like the name of the
poet A. E. Housman), a transverse of decrepit marvels too
numerous to list, but well worth the walk—among other
wonders I pass a bathtub graveyard behind a chainlink

fence, an open-air Antique and Props Gallery at 76 East Houston, featuring old coke vendors, and a giant effigy of a rat standing inexplicably in the road (which I later learn is a protest against unsafe working conditions on construction sites). Farther on, I see what I can only describe as metal and concrete shelves of stacked up parked cars. How do they get them up there?

On my way to Hudson Street in the West Village, I learn that the name of Kennedy has joined that of McDonald's in the world of junkfood chains, as I discover a *Kennedy Chicken* nuzzled wing-to-nugget with a *Mmmmm*cDonald's. Interesting accident that McDonald's chose that arched "m" as its logo. The word for mother in many languages—English, Dutch, French, Spanish, Italian, German, Hungarian, Portuguese, Russian, all the Scandinavian tongues, even Korean and Swahili, and no doubt others—begins with an "m." An infant makes the sound "mmmm" as his lips go for the red nipple; and we still make the sound to indicate that something tastes good. Devilish clever logo, using motherhood to rot our guts.

At 375 Hudson, I meet Jeff Freiert at Penguin, and we lunch on organic hamburgers at Grange Hall—50 Commerce Street, at Barrow. Alas, at this writing, Grange Hall is no longer whinnying with us, although it made its swan-song appearance in the last episode of *Sex and the City* as a Paris bistro. Because Jeff has to go back to work, he drinks iced tea; because I don't, I enjoy a giant "prairie martini." After-

ward, we stroll to nearby St. Luke's Place—a short, leafy, shady row of townhouses that hooks between Hudson and Leroy Streets. Here, across from a playground and the Hudson Park Branch of the New York Public Library, lived Theodore Dreiser (1871-1945) at number 16 from 1922-23 while he was starting *An American Tragedy*, which he completed in a rented office at 201 Park Avenue. Since Penguin recently reissued Dreiser's 1912 *The Financier*, I persuade Jeff to pose for a snapshot on the townhouse stoop displaying the volume.

Bill Morgan's excellent *Literary Landmarks of New York* (New York: Universe, 2002) tells me that a meeting was held on the parlor floor of Dreiser's house here in which F. Scott Fitzgerald, Horace Liveright, H. L. Mencken, and Carl Van Vechten discussed strategies for Dreiser's work to evade the wrath of the censors who had been plaguing him ever since *Sister Carrie* (1900) for "too vividly describing the seamier sides of life," though perhaps also because of his championing of economic democracy; he died a communist in 1945.

Number 14 St. Luke's Place was the home of Marianne Moore (1887-1972); in the early 1920s, her mother shared the basement here with Moore who worked across the street in the library. In 1929 she moved to Fort Greene, Brooklyn, but returned later to the Village, when she lived at 35 W. 9th Street. In 1951 Moore's *Collected Poems* won the National Book Award, Pulitzer Prize, and Bollinger Prize. A little sign on the door lintel of no. 14 proclaims "Peace and Love" in

letters of modest size. It always has seemed to me that read-
ing a single poem thoroughly is a job of work, and I recall as
a student having been assigned far more poems to read than
I had time, strength, or inclination for, finding succor in the
first line of Moore's "On Poetry": *I, too, despise it...*

Number 12 St. Luke's was the home of Sherwood Ander-
son. Morgan tells of Anderson's having to work up the nerve
to knock on Dreiser's door to introduce himself, only to have
it shut in his face after a curt greeting; Dreiser, it seems, was
also shy before Anderson, but the two later became friends
and Anderson also attended the anti-censor strategy plan-
ning session described above. No plaque commemorates
Anderson's residency here. Indeed, the only sign evident ad-
vertises the house for sale—information from Jaime Farmer
and James Roubul at 212-588-9490. Cell phone in fist, I con-
sider calling to ask the price but decide against depressing
myself.

Jeff returns to work, and I am startled from my leafy,
shady, post-martini reveries of famous poets and fictioneers
by someone shouting out in the hot yellow sunlight on Hud-
son. A man is running, yelling, on the pavement across the
street while a red-headed man with a movie camera runs
backward away from him, filming. Unlike the time I saw a
news stand clerk with a hammer and cigar box chasing Dus-
tin Hoffman on Fifth Avenue some 35 years ago (a scene
from Ulu Grosbard's 1971 film, *Who Is Harry Kellerman and
Why Is He Saying those Terrible Things about Me?*), I do real-

ize this is a film in progress and successfully resist the impulse to intervene, other than to join the melee with my own camera. The running man is wearing a costume I can only describe as resembling a six-foot turd.

The camera crew takes five, and I sidle over to ask the costumed man if I might do a portrait. He appears pleased to comply.

I ask what the film is, and he tells me it is an ad for Dentyne. "You know? The gum? Cleans your teeth?" Ah! Not a turd but a personification of tooth decay, oral bacteria, gingivitis.

Where St. Luke's meets Seventh Avenue is a short turn north from a cluster of small old-world-style streets crammed with literary history. "The narrowest house in New York," at 75½ Bedford Street, between Commerce and Morton Streets, bears a plaque commemorating Edna St. Vincent Millay (1892-1950) who lived here in 1923-24, the year she won the Pulitzer Prize for her poetry collection *The Ballad of the Harp Weaver*. Among others who have lived in the house are John Barrymore, Margaret Mead, and Cary Grant. The plaque above the door quotes what are perhaps Millay's most famous lines, testimony to her relatively short life:

My candle burns at both ends.
It will not last the night.
But oh my foes and oh my friends,
It gives a lovely light.

Beneath the plaque an elegant lamp illuminates the door lintel.

Farther along Bedford Street, at number 86, between Grove and Barrow, is a most remarkable place behind an unmarked door one would be likely to pass without notice unless forewarned—the restaurant, bar, and former speakeasy which since 1928 has been frequented by more writers than perhaps any other single bar, or three, in New York, or anywhere: Chumley's.

Established by Leland Stanford Chumley, an organizer of the International Workers of the World (IWW), a former laborer, soldier of fortune, stagecoach driver, wagon tramp, waiter, artist, newspaper cartoonist and editorial writer, and taken over on his death by his widow, Henriette, from 1935 until her death in 1960. Since then, it has continued under a number of owners and managers without changing character.

What is now the main entrance at 86 Bedford was formerly an escape route during prohibition raids up to 1933 when the Volstead Act was repealed. In those days, the entry was through an archway at 58 Barrow Street, through the Pamela Court backyard to a very speakeasy-looking door within. When the cops came to raid, Chumley would detain them at the door while customers were advised to "86 it"—to take the 86 Bedford Street exit.

Chumley's has been host to James Agee, Djuna Barnes, Brendan Behan, John Berryman, Humphrey Bogart, Vance Bourjaily, William Burroughs, Willa Cather, John Cheever,

Gregory Corso, Malcolm Cowley, e. e. cummings, Simone de Beauvoir, Floyd Dell, John Dos Passos, Theodore Dreiser, James T. Farrell, William Faulkner, Edna Ferber, Lawrence Ferlinghetti, F. Scott Fitzgerald, Alan Ginsberg, David Ignatow, Erica Jong, Buster Keaton, John F. Kennedy, Jack Kerouac, Ed Koch, Ring Lardner, Jr., Sinclair Lewis, Norman Mailer, W. Somerset Maughm, Mary McCarthy, Margaret Mead, Edna St. Vincent Millay, Arthur Miller, Marianne Moore, Anaïs Nin, Eugene O'Neil, Henry Roth, J. D. Salinger, Delmore Schwartz, Upton Sinclair, John Steinbeck, William Styron, Dylan Thomas, Lowell Thomas, James Thurber, Edmund Wilson—and that is only a few of them. According to a rumor, furthered by David Yeodon and Roy Lewis, even James Joyce is said to have written a couple of chapters of *Ulysses* at a corner table here, though of course this is nonsense: *Ulysses* was completed before Chumley's ever was Chumley's, and Joyce never even made it to New York City.

In her 1948 book, *America Day by Day*, Simone de Beauvoir wrote:

In Bedford Street is the only place in New York where you can read and work through the day, and talk through the night, without arousing curiosity or criticism: Chumley's. There is no music so that conversation is possible. The room is square, absolutely simple, with little tables set against the walls which are decorated with old book jackets. It has that thing rare in America: An atmosphere!

I myself frequented the place in the late '60s and early '70s—when I could find it. Usually I went there with a few under my vest (as the Danes say) and rarely could find my way back again sober. I recall arguing with a girlfriend in the Bedford side alley, behind the door camouflaged as a tall narrow shelf of wooden book facsimiles, painted and carved with intricate verisimilitude. I don't recall the argument, only that I sulked in the alley for a time singing, for some reason, "*Wi-ild ho-orses! Woulden drag me a-way...*" while she sulked in Pamela Court, and my friends Jay Horowitz and Barry Brent sat inside looking for Ferlinghetti's "beautiful dame without mercy picking her nose in Chumley's."

Here, too, I ran into Gregory Corso on his 40th birthday when he tried to sell me what he purported to be the first postage stamp ever printed. When I told him it didn't look like an 1854 British Guyana quarter-penny, he embraced me and whispered, "You're a smart man." Still more recently, I recall sitting here one April Sunday afternoon with Walter Cummins, editor of *The Literary Review*, having been driven from The White Horse (where Dylan Thomas drank his fatal whiskies) by a visiting New Jersey band of kilted bagpipers in their cups.

Today, I've found it after only a single martini and let myself in the unmarked 86 door, excuse myself past a tall man with long grey hair and a beautiful woman with a tall exotic dog. Another man with a broom is sweeping around the bar, and I order a pint of Chumley's own pilsner. The tall

man tells me the place is closed, but because I have been looking reverently at the book jackets on the walls, my order is filled, and he shows me around. His name is James Dipaola, and he seems to be the curator. He shows me the centerpiece jacket, titled *The Unknown Book* by Unknown Writer; where the author's photograph should be on the inside French flap is a small mirror—a tribute to all the patrons who have labored to produce books that never saw print. The beautiful woman with the dog—a sleek-coated half English pointer named Maverick—is Gina, a bartender studying at NYU. Jim Dipaola presents me with a pamphlet the size and shape of a bookjacket complete with French flaps, titled *Chumley's, A Historic Narrative by Leland Stanford Chumley.*

Jim invites me to send him the jacket of my own most recent book along with a signed photograph of myself, preferably with a dog if I have one, so that he can add it to the collection on the walls. A few weeks later, I do so, and I hereby urge all reading this who visit Chumley's to investigate whether the jacket of *Kerrigan's Copenhagen, A Love Story* and/or *Bluett's Blue Hours* by Thomas E. Kennedy have been added to those venerable walls.

Reluctantly, I leave Jim and Gina and Maverick and the comfort of Chumley's, bound for Grove Court between Bedford and Hudson Streets where O. Henry's daughter is said to have lived and which is said to have been the inspiration for the setting of O. Henry's "Last Leaf." It is easy to imag-

ine this as the place where Johnsy lay withering and waning in her bed, watching the leaves of an ivy vine on the brick wall outside her window disappear by the day along with her strength and where the unsuccessful abstract artist, Behrman, refurbishes her will to live with a realistic painting of an ivy leaf on the wall—at the cost of his life; he falls from the ladder into the snow and, drunk, unable to rise again, freezes to death. As all of O. Henry, melodramatic, sentimental, contrived, moving and unforgettable—it sticks like gum to a shoe. The gate to Grove Court is locked behind a sign that sternly identifies it as private—an elegant place that once was a home for the struggling poor.

O. Henry is of course all over the city, not least in the excellent Pete's Tavern at 129 East 18th Street that I won't have time to visit today, though often have in the past, sitting whenever it is vacant at the booth by the front doors where O. Henry wrote "The Gift of the Magi"—another of his unforgettable concoctions. Pete's Tavern has been in continuous operation since 1851, first as a "grocery and grog," during prohibition disguised as a flower shop. The kitchen is Italian, the food excellent, the martinis near psychedelic.

I am now headed for Carpo's. I cross Sheridan Square at West 4th and Christopher, where I stop to marvel at the irony of juxtaposing sculptures of General Sheridan in dark heavy bronze and two life-sized gay couples with white-painted finish by George Segal (1924-2000) commemorating the birth of the Gay Liberation Movement in 1969 when the police tried

to raid the Stonewall Bar at 51-53 Christopher Street looking to suppress homosexual activity and found, to their surprise, a gay clientele not willing to lay down and whimper. It took some doing and many years before the city finally allowed this memorial to be christened in 1992.

Across the street at the Village Cigar Shop, I purchase from a dour clerk a fresh, $8.00 Partagas, rolled of "100 percent tobacco" grown on Cuban seeds, which—while across the avenue yuppie types dine on expensive junk in the Gourmet Garage—I smoke at an outdoor table of the Riviera Café, nursing a bottle of Heineken. I gaze across to the Segal sculpture, considering how at least some aspects of life have improved. On the outdoor table where I sit, a sign informs me that smoking is permitted, though the Surgeon General wishes to remind me it is a nuisance for others and a danger to myself. The Surgeon General makes no comment on the carbon monoxide fumes pumping from the pipes of scores of gasoline-burning automobiles that roll past just below my nose.

The only other customer is a young businessman at a nearby table. He sits over a juicy Riviera burger and speaks into a cell phone: "No no no, Chuck, no. You meet me here, you'll meet a tonna fuckin' people, ya know what I'm sayin'? Ya know what I mean? Don't meet me here."

From Sheridan Square is a short walk over 4th to 189 Bleecker at Macdougal Street to Carpo's, formerly San Remo's, where I order a $5 Heineken from a sweet-faced

waitress and sit at a table out on the narrow strip of Bleecker sidewalk. Here in the free and open air, an endless fleet of yellow cabs excrete carbon monoxide into my air. I deserve it, I think, lighting a Petit Sumatra. The formerly smiling waitress descends upon me with wrath: "You cannot smoke here, *sir!*"

"Actually," I explain feebly, "I don't inhale."

"Well *I* do, sir!"

I stub out the lovely, barely-smoked Petit, apologizing. "Have a good monoxide."

At a table behind me, two attractive women chortle, one blond and the other auburn-haired, the latter wearing high heels and a polka-dotted summer dress that strikes me as 1950s.

"Are you dreaming of San Remo?" I ask. The brightness of their quizzical smiles tells me they are either out-of-towners or hard-core members of the post-911 corps of pleasant New Yorkers. I recently heard someone bemoan the passing of the rude New Yorker: *If only someone would growl at me, I'd feel like things were safe again!* The first 30 years of my life were spent here, and I know the New York crust covers a blunt but friendly heart; I wonder what the new New York smile might cover. (As my father wrote, "A frowning face you may trust and like / But who can say when a smile may strike?")

I explain to the ladies that Carpo's used to be the San Remo Bar, opened by Joe Santini in 1923, a Bohemian head-

quarters until well into the '50s where the regulars included people like James Baldwin, William Burroughs, Gregory Corso, Miles Davis, Norman Mailer, Jackson Pollock, William Styron, Dylan Thomas, and Tennessee Williams. Jack Kerouac was a regular for years, and it served as a model for the café "Mask" in San Francisco in his 1958 novel, *The Subterraneans.* According to Bill Morgan, the idea for the Living Theater was also born here.

"Oh!" says the polka-dotted young lady, who introduces herself as Shari, "I'm studying acting myself. In San Francisco." It turns out she is the daughter of the other young woman, from West Virginia, who confides to me she is 40. I had thought they were both around 27, but it seems too feeble a line to pitch. "Why don't you go knock on the door of the Actors Studio while you're here?"

"That's exactly what I told her," the mother says. "Tell her to do it."

"Do it, Shari," I say, though actually I walked past the Studio earlier in the day and the front doors were wide open, but with a chain across them on which hung a sign that read, *This is not an entrance.* Which I suppose could be interpreted in a number of ways. Considering how to tell about that inspires me to recommend a visit to the Actor's Playhouse where these ladies might see *Naked Boys Singing.* "Talk about a show with balls!" as *Time Out New York* put it, but I am suddenly distracted by shouting on the other side of the street, and a cameraman runs past my table on the sidewalk.

His red hair looks familiar. Then I notice a guy yelling and dressed up like tooth decay.

"You guys get around, don't you?" I call to the camera-man, who flips me a smile, and the West Virginian mother asks if I will introduce her, as she is a photographer herself. "I've taken some good pictures," she says, "some of Shari, too, even where her ankles don't look so thick."

But the cameraman and the sprinting decay already are gone, and I finish my beer, bow and take my leave, on to Patchin Place at West 10th between Sixth and Greenwich Avenues. Here, at 4 Patchin Place, lived Edward Estlin Cummings (1894-1962) from 1923 until his death. I recall cummings' outstanding line, "there is some shit I will not eat," and wonder if I can boast the same. Among cummings' houseguests here were Eliot, Pound, Dos Passos and, Bill Morgan notes, "a very drunken Dylan Thomas."

In the late 1950s, cummings was also once arrested for public urination on the Rue Git-le-Coeur in Paris, described on the French police blotter as "*un Américan qui pisse.*" Rue Git-le-Coeur 9 is where the so-called Beat Hotel used to be, where Burroughs, Ginsberg, Corso, Kerouac and others used to stay. It is still a hotel, though not a Beat one and certainly not at Beat prices. So it goes with all places once Hip or Beat or Bohemian. Commerce moves in like a plague of affluent cockroaches and the native cockroaches move out, taking everyone authentic with them.

Across the narrow way, at 5 Patchin Place, Djuna Barnes (1892-1982) lived reclusively for the last 42 years of her life. Her best known novel, however, *Nightwood* (1936), was written in Paris where she lived until the war forced her home.

Other literary residents of Patchin Place at various times include John Reed (1887-1920), "terror of the industrialists"; John Masefield (1878-1967), in the years before his four decades as poet laureate of England; the Irish writer Padraic Colum (1881-1972) and Jane Bowles (1917-73).

As a youngster I hated memorizing dates. In those days, more than ten years ago seemed lost in the ancient fog. Now the years enchant me, affording a glimpse of how short time really is—a century, a lifetime. At the moment, I am reading Tolstoy's *War and Peace*, which begins in 1805—nominally a distant time. But having lived more than half a century myself and half of it in the ancient kingdom of Denmark gives another perspective. 1805 is just two years earlier than the year that the Duke of Wellington shelled Copenhagen, killing thousands of civilians and blowing the roof off one of my favorite bars and jazz places—The White Lamb on Copenhagen's Coal Square. I love to sit there over a pint, contemplating the fact that Søren Kierkegaard in the 1830s lived across the street and that the Duke of Wellington is now dust in his grave and the only duke who blows the roof off that bar now is Duke Ellington.

Looking backward, time is really not so long. When I started college in 1961, the four years to my BA seemed an insufferable length. Since then, I could have taken nearly a dozen BAs. In fact, I like to think—to hope at least—that every unit of four years that I live teaches me as much as four years of college would. Since in total my BA, MFA and PhD took me ten years, could I not now claim to have four PhDs and on my way to a fifth?

In Germany, multiple PhDs are awarded and titled. A German colleague named Link once approached me asking, "I understant you haf a PhD?" I acknowledged that was true, whereupon he smiled as though he had just beat me at ping-pong and pronounced, "*I* haf *two* PhDs." So he was Dr. Dr. Link. Might I now claim to Dr. Dr. Link to be Dr. Dr. Dr. Dr. Kennedy? Why not? I once knew a man titulated Professor Dr. Dr. Sewering. But unfortunately both he and Dr. Dr. Link disappeared some time ago and no one seems to know where. So he is now known as the Missing Link.

Farther north and east at 14 West 10th between Fifth and Sixth Avenues, at the beginning of the 20th century lived an author not commonly associated with the Big Apple: Samuel Langhorne Clemens, aka Mark Twain (1835-1910). In fact, according to my guidebook, it was in New York that Twain first donned the white serge suit that became his trademark.

On East 10th Street at number 18, Emma Lazarus (1849-1887) resided, author of the 1883 sonnet "The New Colossus," which contains perhaps the most quoted lines of any

American poem, inscribed in the pedestal of the Statue of Liberty:

> *Give me your tired, your poor,*
>
> *Your huddled masses yearning to breathe free,*
>
> *The wretched refuse of your teeming shores,*
>
> *Send these, the homeless, tempest-tossed to me,*
>
> *I lift my lamp beside the golden door.*

These days when one enters the country, by flying ship, the poetry of welcome takes the form of questions printed on a green form about whether one suffers from contagious diseases or mental illness, whether one has ever been arrested for a serious crime, engaged in espionage, sabotage or moral turpitude: Answer yes or no, please.

Or as Lou Reed puts it in "Dirty Blvd.":

> *Give me your hungry, your tired, your poor, I'll piss on 'em*
>
> *That's what the statue of bigotry says*
>
> *Your poor huddled masses, let's club 'em to death*
>
> *And get it over with and just dump 'em on the boulevard*

At 23 East 10th on University Place, in the Albert Hotel's room 2220, from 1923 to 1926, Thomas Wolfe (1900-38) stayed while he taught writing at NYU (imagine taking a workshop with Wolfe: *This prose is much too bland; purple it up!*) and worked on *Look Homeward Angel*—"...a stone, a leaf an unfound door..." In his *Of Time and the River*, The Albert appears as the Hotel Leopold.

Wolfe—and many other writers, artists and musicians—also stayed for a time at the Chelsea Hotel between 7th and

8th Avenues at 222 23rd Street. The Chelsea's many celebrated guests included Arthur Miller, Dylan Thomas, Mark Twain, O. Henry, Edgar Lee Masters, James T. Farrell, Mary McCarthy, Brendan Behan, Arthur C. Clarke, Nelson Algren, Nabokov, Yevtushenko, Burroughs, Corso, Ferlinghetti, and the punk rocker Sid Vicious of the Sex Pistols who murdered his girlfriend in Room 100 here before ending his own life, although there have been later assertions that both were murdered by a third person. (Room 100, I am told by the management, no longer exists, having been dismantled and subsumed by two adjoining suites.) Bob Dylan, too, in his song "Sara" on the *Desire* album, reports having written "Sad-Eyed Lady of the Lowlands" in the Chelsea.

Intriguing to note that a few doors down from the Chelsea is, or was, an SM Restaurant in which one could order an appetizer of soup to be eaten from the floor like a dog and for dessert a paddling on the bum. What an appetite!

Among the fiction of Thomas Wolfe is the extraordinary story "Only the Dead Know Brookyln." It seems to me only the dead could know the immensity of New York's literary history. I give up, refrain from visiting Kerouac's apartment at 454 W 20th between Ninth and Tenth, or Auden's at 77 St. Mark's Place between First and Second, or the statue of Washington Irving at Irving Place and 17th Street.

Instead I head back to my hotel, still on foot, wading through the heat of the darkening afternoon up through Hell's Kitchen and Eighth Avenue again, past PeepWorld

and the Playpen and a great big American flag beneath a sign that orders God to Bless America. Farther on to the theater district and a large likeness of a smoker hiding between buildings, sneaking a weed.

It is dark by the time I reach the Hotel Carter on 43rd Street between Seventh and Eighth Avenues, a family-owned hotel recommended to me by Mike Lee of the *Cape Cod Voice*.

Once known as The Dixie, the Carter was subject of an April 1986 *Village Voice* exposé by Laurie Stone entitled "Heartbreak Hotels," about the more than 3,000 homeless families temporarily housed in run-down, overpriced hotels. Clearly, the Carter has seen better days as well as worse days—it's currently rated 1½ stars—but on the Manhattan hotel market it can hardly be called overpriced today. My room on the 21st floor costs $89 a night (at the time of this writing raised to $99) and has a view, or a scrap of a view out the bathroom window, of the Hudson River. I am in room 2131, which is about 7 by 15 feet with a ten-foot ceiling, a walk-in closet which looks like a basement utility room, deckpainted green. There is a good bathroom with a clean if unappetizing bathtub, three windows, three good mirrors— one strategically positioned at the foot of the king-sized bed for those who like to watch themselves *en embrace*. Above the bed hangs a single, faded, framed print that seems to want to simulate Paris, and another view out the windows in the sleeping room down to the traffic on 43rd and Eighth.

At night when the tall narrow neon sign that climbs the outer wall blinks on, the name of the hotel changes to HOTE CAR E —the L, T and terminal R having burnt out a couple of years before. It occurs to me that if the E's go, one at a time, in succession, the hotel will assume, by turns, the names HOT CAR E and HOT CAR, maybe at some point it will be just HOT.

Hot it is tonight as I greet the night manager, Abdul, seated at a desk and swivel chair in the middle of the broad dim lobby.

"Abdul," I say. "Are you aware that Joe Buck, played by Jon Voigt in the 1969 film *Midnight Cowboy*, stayed here just after he rode the Greyhound dog in from Texas? If you look quick in the film, you can see part of the long sign on the outside wall."

"I know Joe Buck," he says. "He was cowboy. With the cowboy hat and the buckskin fringies. But he smell bad," Abdul adds, waving his fingers before his nose.

"See him lately?"

"I think he move south. Florida maybe."

Why not? I think. How much of what we think we know is fictive hearsay? Does it matter? The only hard facts that count belong to bridge-builders or aeronautical engineers or surgeons. Reality otherwise is but a point of view, and if you combine angles, you get a hodge-podge of points of view, signifying little other than something to partially satisfy our ignorance of existence. You get a cubistic consciousness—like

a fly's eye view of the world. A fly can walk on the ceiling. But on cubistic feet you can hardly negotiate a floor.

"You know Joe, then, Abdul?"

"I know Joe a lit-tle," he says with an amending tone. "Not that well."

Abdul knows I am writing about New York and invites me to join him in the elevator to visit the ghost floor on 24, peopled now by old laundry wagons full of discarded cables and bedding, old mattresses and other rubble. A sign on the wall still advertises the defunct Circle Bar and Lounge and Terrace Restaurant (Dinner from $3.75, lunch from $1.25), but the stairway to the roof is impassable, blocked with chunks of plaster and refuse.

Just as well. I retire to my Bogart noir room with its battered mismatched furniture, a bed table with a drawer but no pull knob, a plastic chair. Thank god it has functioning A/C. I drink a tepid cocktail of Stolichnaya from a cellophane toothbrush glass and munch a turkey curry sandwich purchased from the 24-hour deli that adjoins the lobby, watching kids skateboard a few floors below on the roof of a building across 43rd.

It occurs to me that the New York of those kids is one I will never know. And perhaps they will know little of the New York I see, certainly of the New York I saw decades ago, in the last century, the last millennium.

William Sidney Porter (1862-1910), aka Oliver Henry, aka O. Henry, wrote his New York tales of *The Four Million*

(1906), and each episode of the 1960s TV series about New York, *The Naked City*, concluded, with an oblique, updated reference to that: "There are eight-million stories in the naked city. This has been one of them."

It seems to me now, watching those roof-top skateboarders whom I will never know, that perhaps there are eight-million New Yorks and three-hundred-million Americas.

No one will ever know more than a tiny fraction of them.

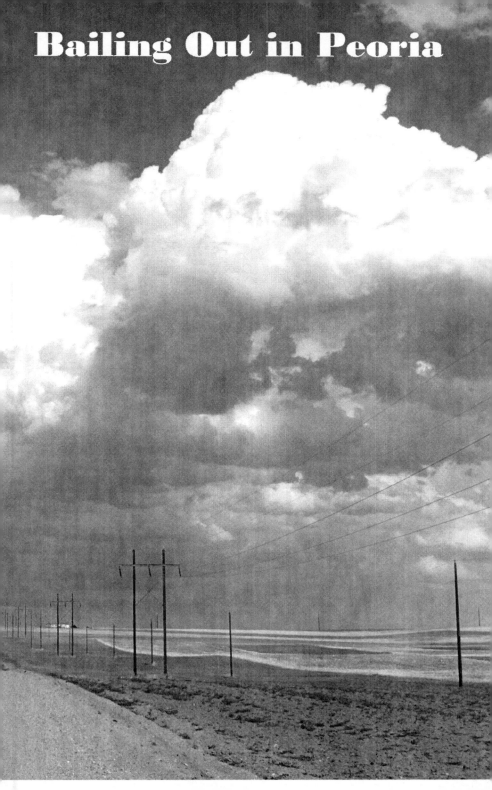

Bailing Out in Peoria

SUNDAY, AUGUST 20TH—Across the George Washington, on the west side of the Hudson, with sweaty hands, Nick and I lift our bikes from the back of the pick-up, securing the baggage strapped to the carriers. Late afternoon humidity and temperature run neck and dripping neck in the high 80s. I am tight on farewell beer, shirt stuck to my back and belly, and this long-discussed trip, now beginning, feels unreal. *Am I really doing this?* Big Nick's jock-grey, sawed-off St. John's sweatshirt blurs dark beneath the arms, and from the grin on his ruddy puss I guess he's tight, too. The pick-up driver, Jimmy, a short chesty ex-Marine, twenty-three years old, my age, ceremoniously shakes our hands.

A dozen friends from the Friendly Tavern, where we were held captive since noon, Sunday opening time, stand outside their cars in the dusty cut-off of the old two-lane, the Lincoln Highway, established in 1913 to span the continent. I remind myself to lift my leg high as I swing up onto the bike, to clear my deep-packed baggage and avoid the humiliation of starting the journey with a flop, leave them with that image as we set off, their laughter chasing us.

Someone toots his car horn, and a cheer goes up. The young women in hip-hugger bell-bottomed jeans, long flowing '60s hair, middie blouses, wave, navels winking as we put feet to pedals and begin to pump. We lift an arm in heroic

Roman salute as beer churns in my belly, the surreal *US 1* sign looming ahead, our rear carriers weighed down with nearly a hundred pounds of gear—shelter halves, sleeping bags, ground mats, tent poles, pegs and ropes, powdered and canned food, a sterno-stove, and in my case a fat Webster's which I never travel without, in Nick's a 30/30 lever action rifle and box of ammo (Nick supports the NRA and the constitutional right to bear arms). As we round a curve in the narrow highway, I hear the motors of our escort revving up behind us to head back to Queens and the lazy pleasures of the air-conditioned Friendly Tavern. Queens. I am leaving Queens behind. Leaving behind my dead father.

Bye-bye, New York. Howdy, East Orange.

This was 1967. I had decided to ride by bicycle from New York to San Francisco. The bicycle was a three-speed Schwinn, banged up as my life. This symbolic journey was meant to trim the beer fat off my body, tighten my muscles, give me a tan. More important, to make of me a young man who had bicycled across the American continent. Already I had become a young man who was going to bicycle across the American continent. Now I only had to do it.

And then I would return in triumph to the City College of New York from which I had taken a leave of absence in 1962, at the age of seventeen, after my first semester, to become a writer. Who needed a degree? John Steinbeck didn't have a degree. Ernest Hemingway didn't have a degree. William Faulkner, J.

D. Salinger, Jack Kerouac didn't have degrees. During the 5½ years since dropping out, my father had died, a fact still foreign to me, and I had lived in a variety of crummy apartments in a variety of cities, surviving on onions, tomatoes, rice, and generic beer and wine. I had also filled a lot of spiral notebooks describing my journeys around the U.S. on Greyhound and Trailways buses and in various cars which had stopped on various roads in various states at the request of my thumb—as well as other, inner journeys, fueled by alcohol and psychedelics and about my hated time in the army, pre-Vietnam. But nothing I wrote had earned more than a printed, impersonal rejection slip.

In fact, a few months before, my collected writings to date, locked in an attaché case, had been stolen from a locked '66 Ford on Fillmore Street in San Francisco. I can still imagine the incredulous, disappointed scowl on the face of the poor junky when he jimmied the attaché case locks to find nothing inside but a mass of scribble. Not even a junkie wanted to read me.

Clearly I needed to find my way back to some kind of normal, sane life—the life I used to have, before my father's drinking turned fatal, before it killed him. So I cut my long hair, shaved my burns and 'stache, and enlisted Nick to accompany me on the crossing. Nick seemed a model of normal American youth. He had played football for St. John's where he majored in German; he stood half a foot taller than me, had a powerful body, a broad, underslung jaw, and a crewcut. And, though a football injury had prevented him from serving, he supported the Vietnam war. As long as we didn't talk politics, we got on fine. For

some reason, I've always hit it off with jocks, despite that I never once in my life, apart from a semester of mandatory soccer and lacrosse at CCNY, had had a thing to do with balls or bats or hoops.

Our plan is to cross the continent on the less trafficked Lincoln Highway rather than the other, more contemporary Route 66 of Nat King Cole and Rolling Stones fame. The Lincoln passed from New York and New Jersey through southern Pennsylvania, a sliver of West Virginia, the northernly bits of Ohio and Indiana, slashing down to central Illinois, Iowa and Nebraska, through Nevada to Reno and on across northern California to end in San Francisco—where we hope to arrive on November 1st. Our journey has been lined out for us by a white-shirted, bow-tied Esso PR man in mercurochrome-colored highlighter on a series of promotional road maps. We will ride idyllic farm roads, see the real country, coast through small-town America, where smiling families will wave from white wooden porches, farmer's daughters will offer drinks of cool white milk from aluminum buckets, gazing at us with shy, admiring eyes. We will meet the real people. And—I will find out—their real dogs, too.

Despite Nick's history as a German-speaking jock, I am, at least initially, better prepared for the trip than he because I have been biking a couple hours a day for months. Nick only purchased his bike—a brand-new five-speed—two weeks before. Now we are on the road, me and Nick, sweat-

ing, our seat heights adjusted just so for the full thrust of leg, thigh muscles flexing as we pump pedals, turning sprocket and chain and wheels along some backroad through a Jersey swamp, headed toward the sun as it flattens red as a bruise along the blue horizon.

Before long we are coasting up to a camp ground, eerily misted in the gloamy dusk, pay fifty cents and hunt through the marshy trails for a spot to pitch our pup tent. I roll my bike behind Nick, in short pants and tee shirt, and watch his thick, mossy arms and legs quickly cover with red welts from the stinging, whining mosquitoes; I thank the gods of chance that have me wearing long sleeves and jeans. Actually, though, it is the gods of poverty—I don't even own a pair of shorts—or a decent set of clothes for that matter. I am an impoverished artist trying to get back into the mainstream. I wear two-dollar Army-Navy jeans and my old Class-A khaki Army blouse, white spaces where the PFC stripes and marksman's badge were, lapels tugging at the button over my beer belly. My only luxury in life has been the 15-cent eight-ounce glasses of tap beer I drank at the Friendly.

Nick never utters a complaint about all the bites. Soon he is snoring in our steamy pup tent while I lay awake, smacking my ears to silence the buzz of mosquitoes, thinking. In a sense this is the trip my father once promised me I could take when I turned sixteen. I was twelve then and he thought I'd forget, but on my 16th birthday, when I reminded him, he reneged. Then, however, it was only to have

been an overnight camping trip by bike. Now he is no longer around to stop me, and I am setting off for months of nights, thousands of miles. Not that he could stop me anymore anyway, even if he was still alive. Even when he *was* around, he had been unable to stop me from dropping out of college—he didn't even try. He let me do what I wanted—which I didn't really want him to do.

In the morning, we sit on twin rocks, waiting for coffee water to boil over the slowly crawling blue flame of our little sterno stove, but the cool dawn air heats more quickly and turns sodden.

Nick asks me, "Are you sore?"

"No."

His blue eyes are incredulous in his freckled, pug-nosed, square-jawed face. "You're not stiff?"

"No."

He looks away, shaking freeze-dried coffee grains into the curved tin cup that fits onto the bottom of his army surplus canteen and says nothing more. But it is enough to tell me that his muscles are lumped with pain, shot through with lactic acid. In but a day or two, he will be in better biking shape than I, and every time we take a break, if I show signs of wishing to stretch it out or knock off for the day and find a place to drink beer—which is virtually constantly—will suggest in a brisk tone, "Come on, Tommie. Let's push on. Couple more hours." He calls me Tommie, a name my mother

had with success prohibited anyone from calling me. And he cannot be induced to take a break unless for a skinny dip in pond, lake, stream or river. He seems to consider it his natural obligation to strip and swim in any body of water which enters his field of vision—will even insist we pedal miles out of our way when he spots a glint of water far off the road.

Pennsylvania, August 22nd-31st—Soon we have traversed the swamps of the Garden State and are onto the rising, dipping roads of Pennsylvania, pumping up hills as far as we can, our ascent slowing as our grunts increase until, often as not, we have to dismount and push the bike up the last fifty yards of baking black tarmac. Then we are on the crest and zooming downward, cool breeze rushing across our cheeks as our faces split the air, hoping to maintain speed to carry us up to the top of the next hill. Nick has the weight on me, thus a constant advance of 20 or 30 yards. He flies past farm gates with a milk-curdling whoop, alerting the dogs inside to race out to the road just in time for my appearance—barking, snarling as they sprint along on either side of me, trying in vain to catch my ragged jean cuffs in their snapping jaws as I pray to maintain momentum, not to have to dismount.

I have to dismount anyway and am surrounded by four or five snarling mutts of all mixes—flat-faced, long-snouted, low-legged, short-haired, shaggy, kinky-furred, broad-backed, huskies, all wanting nothing more than an excuse to jaw my ass as I hump my butt-heavy bike up toward the

hilltop, doing my best to ignore the growling curs, fearing fear itself as I wonder whether it is true that dogs can smell fear and instinctively attack the smell. But then I am on the bike again, pumping like mad and the dogs launch after me in frenzy until I loop over the top and pick up enough speed to leave them behind, only to repeat the process halfway up the next hill.

Our first Pennsylvania night, after dragging our loads up a long steep piece of highway to the top of a plateau, we find a wooden lodge with a two-bed room for a dollar a bed. We are the only guests and, after meatloaf and mashed potatoes at the local diner, sit on the porch sipping bottles of Yuengling beer while polka music plays softly from a radio inside. The porch looks out from the edge of the plateau, and we look out over the landscape which will confront us next day—more hilly woods, red barns, fields, farm yards, as far as the distant horizon. It appears gentle now, washed in the soft red light of last sunset. The lodge owner has joined us, a man of fifty or so, craggy-faced, barrel-bellied. His grey eyes grow wistful when he hears we mean to cross the country.

"Always wanted to do that myself," he says softly, gravel-voiced. "In a horse wagon. Camp by rivers. Cook meals on a wood fire."

I am still thinking about the dogs and manage to drag them into the conversation. "I guess they're just playful," I suggest hopefully.

He turns his eyes to me, sharp now, drawn from their dream. "Oh I don't think so. They ain't playin'. They likes want a piece of you."

Which reminds me of a sign I saw in a diner where we stopped for lunch; a thick-backed short-snouted brown mutt strained at its chain outside beneath a hand-painted sign that said, *Mean Dogs Make Good Neighbors.*

That night I lay awake in my bed listening to Nick snore from across the room and think how I am stuck in this journey now. I didn't expect dogs. I remember when I was a kid delivering papers and certain places had dogs—a boxer that leapt up on me and scratched my arms with his nails while he tried to pork my leg panting in my face, two long short dachshunds that came clicking speedily out on their tiny legs yap-yapping me out the gate in fear of ankle bites, a Great Dane that loved to slather his huge drooling tongue all over my face. None of them ever bit me at least. I wonder if I will get bitten by one of these farm dogs. And if, when one bites me, the smell of blood will have the whole pack over me.

I fantasize assembling Nick's rifle, riding along to take one-handed pot shots at the mutts, fire from the hip, flip the lever action like *The Rifleman* on TV. See the biggest of them take a slug in the chest, yip once and bounce and stop dead, blue tongue lolling over now harmless fangs, the others scampering off in a whimper. But I know Nick won't lend me the rifle:

Looking across at the sleeping Nick, I grin like Alfonso Bedoya smiling at Bogey in *Treasure of the Sierre Madre*—I also have a gat-tooth—and whisper, *"I remember you. You were the one who would not give me the wifle."*

Maybe Dad was right to forbid me to go biking off. Or maybe he should have let me do that but not drop out of college. Then I'm thinking about him. He was good with dogs. I remember once when we visited my aunt's summer house at Point Lookout and she had a new dog, a mean-tempered Kerry Blue, who didn't know us, and my aunt wasn't home but the screen door was unlocked. The big, square-whiskered dog growled and barked through the door, and my mother suggested we wait until my aunt got back to go in, but my father didn't hesitate; he just opened the door and ordered the growling dog to go lay down, which it did. Later that day, the thing took the seat out of my brother-in-law's pants for no reason other than that apparently she didn't like my brother-in-law's ass—or maybe she liked it too well.

I can't stop thinking about all the dogs that will be there tomorrow. It's as though they have it in for me specifically, the worthless college drop-out on his bike. *Look! There he is — that jerky kid we used to chase when he delivered newspapers! His old man's not around to protect him anymore. Let's get 'im!*

Tired as I am I can't sleep. Outside our window screen, the air is country night cool, cicadas chirping and I see the green darkness of leafy trees, a sliver of shining moon behind

in the navy sky, asparkle with stars. And I'm thinking about my father.

At the end of the summer of 1964—three years before, when I was twenty—he died. His death was sudden but not unexpected. He was fifty-eight. The reasons for his death were complex, and I have spent the decades since thinking and writing about it, and in the process have learned how ignorant I was and still am about my father. But that ignorance now is an informed igno-rance—an ignorance that occupies a lot of rooms with a lot of doors in an edifice of memory where a man could lose himself looking for answers.

That is now. Back then, as I lay in that metal bed in a wooden lodge on a south-east Pennsylvania plateau, hands be-hind my head, gazing out the screened window into the summer darkness, his life and his death are still as new to me as the night is mysterious and ancient. And my thoughts about him—about how he had just given up—haunt the night and frighten me. In those first years after his death, I felt I was adrift on a vast, boundless ocean.

That I was adrift was not only due to my father's death. There were other factors as well, but many of them were bound intimately to the reasons for his death. If, today, one of my writ-ing students had written the above sentences, I would likely tell him or her, "Too abstract and general. Be more concrete." But perhaps sometimes abstraction and generalization are the quick-est way to the heart of a matter.

A few months after my father died, I had been discharged from the army, a confused young man, and my response to his death was to buy a Trailways bus ticket from New York to Los Angeles, the first of many continental crossings, east to west, west to east, across the south, across the north, north to south... Some Roman poet—Horace perhaps—said something like, "You may cross the land but your soul will follow you."

One thing about my father's death, one important central thing, is that it seems to me he gave up, he despaired. As a young Catholic I learned that the only unforgiveable sin is despair, but in my father's case, I don't believe the despair was fully voluntary. I think he had been driven to it by several factors—his job, his childhood, his wife (who, in turn, was driven by him to quiet desperation), the failures of his children. I will not go into detail, but I will add that to some degree, I think, he was responsible for his own early destruction. He let life happen to him rather than acting. He was a perfect Prufrock, content with tea and cakes and ices, with a few lines of verse and shots of Wild Turkey and a whiff of perfume from a dress, forever turning back to descend the stair. Prufrock was a pale Hamlet, and perhaps I myself am a pale Prufrock. Son of Prufrock, pondering his demise.

He was a kind man for the most. He read to me, told me stories, never struck me—even in his cups, was usually patient, if too often distant. I remember his story of shipping out of New York Harbor as a cabin boy on a freighter in 1921 when he was fifteen, a summer voyage to Mexico. There were open cans of

condensed milk in the galley for the coffee—when you shook them you could hear the cockroaches rattle around inside. The captain was a hard man, used to pinch Dad hard in the soft flesh of his side to emphasize orders. Dad jumped ship at the first port, in the Carolinas. I recall his telling me once how in high school he played baseball and just before the season started the coach began to make cuts. He knew that he would be dropped so he quit first. Months later, on the street, he ran into the coach who asked him, "How come you quit? I wanted you for the team." Maybe that was a parable for my edification—or maybe it was true, a key to his character. He did not have the life he wanted, yet took no steps to change it. Unlike his sister he had not gone to college. He worked in a bank instead of working with the poetry he loved. He tried to be happy at home, but he was not—I remember my mother's sad face as she quietly washed dishes, him trying to come up behind and embrace her for a boozy kiss, her trying to make a joke of it: "Hold off! Unhand me, grey-beard loon!" Which made me laugh. But it wasn't funny. His four children were not doing well either—including the youngest, me, a scholarship boy whom he had expected to be the first college graduate, now a drop-out. Dad's response to these things was to drink, then when things got worse to drink even more, and when he was warned by his doctor that he was killing himself with drink, when his president told him he was fired unless he joined AA, he drank double as much until finally one day he spouted blood like a fountain and died.

My response was to flee.

*

Finally I sleep and wake to a raucous choir of birds, each singing its own distinct voice—chirps, twitters, squawks, clucks, trills, whistles. I picture them in a group, tall and short, small-beaked and long, puff-breasted, multi-colored feathers, as I listen from the warmth of my sleeping bag on the metal bed in the chilly Pennsylvania mountain air. Nick and I eat big American breakfasts in the woody local diner— eggs and back bacon and sausage patties, a mess of home fries and pancakes with butter and Log Cabin syrup, toast and juice and lots of black scalding coffee—fuel for the hills to come. Since we stopped the day before on a rise, we can start today coasting down before the first contingent of dogs are around me.

How like a whining snot-nose I feel, whimpering in my heart about a bunch of dogs, and I turn that self-loathing image of myself into a dynamo that fuels my courage—*Move your butt, you sniveler!* I command myself, and that gets me through the remaining days of the farm dogs. At last I grow indifferent to their snarling, begin to fling shouts and curses at them and am delighted to see confusion begin to shiver in their wet black noses. *Hey,* they seem suddenly to be thinking, *Maybe that guy is strong or something.*

Pennsylvania is perhaps 400 miles wide where we cross it—as the crow flies. As the bike rises and falls, however, I wouldn't venture to estimate the distance we cover. We are

twelve days getting to the West Virginia line. Aside from the hills, we lose two days to an accident.

Outside McConnelsburg, Pa, August 26th—Descending a long, steep, curving decline in south central Pa., Nick keeps gaining in his lead until he is so far ahead I lose sight of him. Which is fine with me. As Kahlil Gibran says, "Let there be spaces in your togetherness." By then, I am one with my bike, take my hands off the handlebars and lace them behind my skull, feel the air stream along my cheeks, ruffling my hair. I steer by leaning, can move my body as I wish without losing balance, and have no fear of losing balance because I can sense the first instant of imbalance and correct it. I sing as I coast round the curves, picking up speed—how fast? Who knows? 15, 20, 25 miles an hour? More? I love it. Not a dog in sight, the occasional pick-up flying past with a beeping salute as I sing Dylan's "Rolling Stone," the Stone's "Angie," Simon & Garfunkel's "America," Chuck Berry singing as only Chuck could sing about escape, about flight, mobility and the inability of the world to get too close to a man whose wheels transform him into a cool breeze...

Around one sharp curve I see Nick sitting on the edge of the road, and I laugh loud. What a great joke! But rounding the next curve down the mountain, I suddenly register the dazed expression that showed in his eyes as I flew past. I take hold of the hot rubber handgrips and ease on my brakes.

Nick had crashed, and his arms and legs are brushburned and peppered with gravel. He'd hit his head, too, and is bleeding and dazed. Whatever the politics of that region might be, there is nothing wrong with their humanity. The next pick-up stops and, without hesitation, drives us, bikes and all, to the nearest medical center, in a town called McConnelsburg, just about midway across the state. There a dark-haired, sweet-faced young nurse tweezes the gravel from Nick's wounds, cleans and disinfects and bandages them. Nothing is broken and his head is okay, too, but we will have to spend a couple of days in a motel. We have been on the road for about seven days.

Nick has been working all year as a claims adjustor and can afford to foot the bill. I can't be happier about having two days off the road while he recuperates and a bent rim is respoked. We eat steaks for dinner and sit on the porch of our tiny motel discussing matters of deeper philosophy, swigging bottles of beer. Nick knows I am incapable of talking sports with him, and his potentially fatal spill has him thinking. He tells me that Goethe claimed he wrote to achieve immortality and asks if that is the reason I want to write.

It seems important to him that that be the reason, so I say, "Not in the least. I write because words are more fun than a football. Anyway, if I publish a book, I might get laid more often."

I know that is churlish of me, but Nick is unflappable anyway. I am still pissed off that the nurse in the little medi-

cal center seemed to treat him with more TLC than neces-
sary. Especially when the beer begins to creep up on us there
on the porch and he tells me that nurse was ugly. She was
gorgeous, but she only had eyes for him. I thought cave-men
had gone out of style. It seemed to me the age of the gentle,
peaceful, compassionate man should have arrived about
then, but women still took to the brute. I even once—I swear
it—saw a girl cross the floor of Nellie Keough's Rose of
Trallee and genuflect to Nick. In my case, they always
seemed to be interested in matters of the intellect, the spirit.
I guess some basic animal truths of human nature are always
valid. And I probably would have been a brute if I were able.

During our hiatus, Nick changes his own bandages a cou-
ple of times, and he is the one who, two mornings later,
wakes me to say, "What do you say, Tommie? Let's push
on."

"Please don't call me, Tommie."

"Why? That's your name."

"Okay, *Nickie*. Let's push on then."

Rested and strong after nine days on the road, the last
two in a cozy motel, we embark under a blue sky, determined
that this will be our last day of Pennsylvania. But the blue
sky whitens, then goes dark, and the gods begin to pelt us
with stinging pebbles of hail. Right in the face. The earlobes,
too, and the naked hands on the handlebar grips. It feels per-
sonal. We reconnoiter under a tree as spears of lightning fly

across the sky. I count seconds to the thunder—flash-to-bang time. The lightning is close.

"Let's push on, Tommie. With the rubber tires beneath us, we'll be insulated."

I would have argued but what use is there in huddling wet under a tree? So we don our ponchos and on we push in the rain. How grey and wet and chill it is in late August in a mid-afternoon rain biking up and down the hills of south-western Pennsylvania. It is no doubt a gorgeous region with many interesting topographical features, but I see nothing that day. Grey rain. Dark sky. Even the dogs have lost interest in us.

We pitch our tent that night in a muddy place near a small body of water with a misty rain still wrapped about us. As I crawl into my damp sleeping bag, a large green insect is perched where my head wants to be; it appears to have a toothpick-sized lance on its snout.

"Fuck you," I mutter and crawl in alongside it.

We wake, ravenous, to sunlight and open cans of Warhol beans in tomato sauce which we wolf from the can with our Swiss army forks. As I chew beans I consider the fact that everything I have—jacket, sleeping bag, shirt, jeans, under-wear, socks, sneakers (this was before we called them running shoes)—is wet. Not damp, but soaked. It is our eleventh day on the road, and I try to remember some beautiful sight I have seen. I know that I have seen things, experienced idyllic moments, swimming in a stream in a green valley, say, while

sunlight glinted off the water and willow branches hung lushly down, but at the moment I can remember none of it. I fork up the last of the little red beans and sigh.

Without discussing it, we crumple up our gear and make our way to the high grounds, out of the mud and the wet, and on a stony slope, we strip to our damp swimsuits and stretch out all our things on the grey rock face in the sunlight. The sun is lovely, but we are wet, and I can feel depression seeking to descend upon me. How I yearn for a Twinkie and a beer. A White Castle hamburger and a Mission orange soda. A baloney hero with lettuce and mustard. Words of advice and comfort from my father.

Then I recall once, in 1963, when I was in the army and had received orders to fly from Indianapolis to Washington, DC, arrived at Dulles at one in the morning with all my belongings packed into my duffel bag and a dodgy cardboard suitcase. I was to report for duty at some gate of the Executive Office Building but not before 8:30 next day, and I had no idea where to sleep. Then my suitcase split its seams, and everything in it spilled out onto the pink linoleum floor of the terminal. I gazed down at my belongings—shaving cream and safety razors, hairbrush, toothbrush, toothpaste (I didn't have a ditty bag), a package of 7 -day deodorant pads (for spit-shining my boots), blousing garters, church-key, badges, brass, pens and whatever—rolling and skittering across the floor... I was nineteen years old and wondered if someone would do something for me.

Call Dad, I thought then. He'll tell me what to do.

Fishing into my pocket for a dime, I left my gutted suitcase where it was and headed for a phone booth, composing what I would say to my father. And then it occurred to me that no matter what I said, he couldn't help me. He was hundreds of miles away. It was one a.m. He was asleep. I would have to call collect. He hated it when I called collect—remember that blue lonely evening when you called collect from the Post, desperate to hear their voices, and Dad snapped, "This is costing money, son. What do you want?"—and what could he tell me anyway?

I spotted a newspaper stand and sundries shop where I bought a roll of masking tape, repacked and taped shut my suitcase, looked in the yellow pages under "hotel," found a listing for a Soldier's & Sailor's hostel and slept that night in one of a four-deep stack of bunks with about a foot of stale air between my face and the next bed, wrapped in the snores of the others, feeling I had just crossed over to manhood. Of course, I hadn't. I was still a confused kid. But at least I'd dealt with one situation without calling my father for help he couldn't give.

Now he's dead. And I'm twenty-three. Old enough to be over it. And I am sitting in my bathing suit on a rocky slope hoping that the sun will dry my wet gear before dark. I glance at Nick, marvelling that he has not yet said, "Let's push on, Tommie." He says nothing. His underslung jaw is set, and he plucks at his lower lip as his blue eyes gaze off at nothing.

In the buttoned pocket of my wet army shirt, spread out on the rock, I find a damp pack of Pall Malls and lay them out to dry. Two of them are not soaked through. I offer one to Nick and light us up with my Zippo. He rummages in his bag and finds two cans of beer and punches them open with his oversized brazened church-key. The beer sprays up from the can. He looks silly sitting on the rock face, beer foam dripping from his nose, wearing his checkered swim trunks, surrounded by his spread-out tee shirts and boxer shorts and tube socks, but surely no sillier than I do.

The beer is warm and frothy and bitter. There is nothing else to do but smoke and drink warm beer and wait for our stuff to dry.

I say, "What the fuck are we doing here?"

Nick looks surprised. "We're going to San Francisco."

Scott fucking McKenzie. It is the summer of love, but the summer of fucking love has ended before it even got a name. In truth, though we couldn't have known it then, the summer of 1967 was the end of the innocent '60s—if the '60s had ever been innocent at all. End of the illusion then. We are about to enter ugly '68 where another couple of assassinations will demonstrate that the ones that came before were no fluke; this is America now, this stuff *does* happen here.

But it is still '67, and Scott McKenzie is still singing in his smarmy voice about going to San Francisco and wearing flowers in your hair to meet all the gentle people there. Sure. Tell it to Zodiac.

Our stuff is dry enough that night that we can camp there—down on a wide grassy divider on the highway, tractor trailers roaring past us on either side as we sleep. And next day, August 31st, we stop off in Bentleyville, Pennsylvania, so Nick can cash some traveler's checks at the Peoples Union Bank:

Thursday, September 7, 1967

The Courier, *Bentleyville, Penn. Vol XXI, No. 29*

CROSS-COUNTRY CYCLISTS Nick Slovak, left, and Tom Kennedy stopped in Bentleyville last Thursday afternoon, August 31st, long enough to cash some travelers checks, replenish their knapsacks and explain their stunt to Courier Editor Guy Paul, right. The pair left New York City August 20 with the idea of arriving in San Francisco about the first of November. If their bikes and their legs hold. "We're doing it just as a lark," said 22-year-old Slovak who received his Bachelor of Arts Degree in Modern Languages from St. John's University last June. Kennedy, 23, will return as a sophomore to City College of New York after the trip. "If they'll have me," he commented. They reported the only mishap thus far was a slight spill in McConnelsburg where Slovak received scratches and brushburns to an elbow. Accepting their checks for cashing is Peoples Union Bank Manager Clyde O. Finney as Stanley Beck and Anthony Jurik look on.

In the photograph accompanying the little newspiece, Nick looks healthy and happy and strong. Leaning over my bike, I look like Renfield crawling up out of the hold of Count Dracula's ghostship, crooning, "Spiders, master! *Spiders!*" It would take more than our legs and our bikes for me to hold out for the remainder of this stunt, Guy! Hark, hark the lark's gone dark!

West Virginia—On Friday, September 1st, we wheel past the outskirts of Wheeling, West Virginia, stay that evening in a youth hostel with a big group of kids. Across a campfire, I fall for a young woman with a sweet face though not the world's greatest complexion. But she renders me the kindness of gazing longingly at me. Men and women's quarters, however, are strictly separated in the hostel so we only have time for a walk under the starry night sky and a quick, chaste kiss before the ten p.m. curfew. I ask her for another, and she says no, but gives it to me anyway and touches my cheek, looking into my eyes for one beseeching instant before disappearing into the women's quarters.

What was your name? I miss you.

Ohio—Nick and I roll into Beautiful Ohio, the smoothest part of the journey because we cross on a band of level lowland that runs across the state to the northwestern corner. "Ohio" is from a Seneca word that means "beautiful" or "beautiful river" and it feels mightily beautiful as we achieve

our first of two "century" days—100 miles biking a 12-hour day. But it is also the beginning of my undoing as we pump across the flat country between waving, golden wheat fields.

Wheat. Wheat. More wheat. Wheat.

This is not fun, I think, pushing pedals in September heat, around the fourth hour of the thirteenth day. *Why am I doing this? Just because I said I would? There is no shame in quitting a dumb stunt like this.* I already quit so many things—school, jobs—that shame hardly seems an issue anymore. Then I remember when I went back to college last time, very briefly, the year after I dropped out, then dropped out again after a month, a friend at the Friendly Tavern turned his back to me and muttered, "No guts."

What did he know anyway?

That first day of Ohio we run out of water in the middle of nowhere, and I inhale a floating wheat seed and have to stop short on the highway, coughing, dying for breath. First farm we come to, we venture through the big gate and in along the entry road, expecting at any moment to be attacked by a pack of dogs, but we get all the way to the well where two extremely large men, brothers—wearing peaked caps at a time when no one but baseball players wear peaked caps—come out to greet us in their overalls. We ask if we might take some water, and they bring us icy bottles of coke, sit in the shade with us and ask about our trip. They must weigh 700 pounds between them, gentle-mannered men living, ostensibly, without women or children or anyone else,

expressing wonder at what we are doing. Their farmyard might have been the Garden of the Fintzi Continis, so isolated do they seem. I think of those brothers now, wonder if they are still alive, if their farm has survived.

Canteens sloshing-full of water, we push on, camp alongside the wheat fields, and I dream that the wheat seed I inhaled is planted in my heart and growing. We wake next day alongside the wheat fields, begin biking again along the road between the wheat fields. Wheat. More wheat. I find myself wondering increasingly how to get out of this. It was my idea to start with. How can I quit on Nick?

Then, on a side road through a little town, we hear music. A song I haven't heard before but one that instantly speaks to me: a driving, growling, rolling voice singing words that hook into my viscera, crying out for a ticket to fly, no time for trains—a song about a love letter but to me, it sang of *escape!*

We follow the music through side-roads and come to a public swimming pool—the only thing that can inspire Nick to stop and take a break during this second potential century day. We lock our bikes, dig into our packs for swimsuits, pay a quarter and are in the pool amidst splashing, giggling Ohio girls in two piece swimsuits, the Vox Pops booming from the loudspeaker. It seems to be the only song they play that day which suits me fine. I could listen to it until sundown, eyeballing the muscle tone of Beautiful Ohio's beautiful girls.

My body has already responded to the long days of exercise and sun. I can sense the young ladies returning my appreciative glances, and I think, *Here*. Let's stay *here*. Forever! Let's drop the lark, jettison the stunt, and make a new life right here forever. Maybe those two fat farm brothers would give us work.

One young woman is smiling with apparent appreciation at my unabashed appreciation of her. She is tall, long-limbed, with looong red hair, a little pouch of belly above the bottom piece of her suit where tiny red hairs glint like copper in the sunlight.

I say to Nick, "She will be the mother of my children."

Nick laughs, stubs out his Marlboro. "Come on, Tommie. Let's push on. We can still do another century today."

And we do that.

Indiana—Wheat. Wheat fields. Wheat fields. Wheat.

That is the story of the remainder of the trip. Day after 12-hour day. Wheat fields. No more dogs. No more hills to speak of. Just flat roads through endless wheat fields. And it is like the stultifying sameness of all the days of high school, of college, of jobs I couldn't hold, wouldn't hold, of everything I quit over the past few years because day after day it was too much. *Same thing every day getting up goin' to school...* And just as the wish to quit college had slowly grown in me, so too the wish to bail out on this journey grows as from a

wheat seed in my heart until it is a flourishing stalk that blooms in my mind, leaving room for nothing else.

Laying in the pup tent one evening, head filled with a vision of endless wheat fields, it occurs to me that perhaps my father's life was like this trip. Day after day after day of sameness, no hope for change. Until there was only one way out for him. At the bottom of a bottle of Wild Turkey. And I am thinking about my father again.

Saturday mornings my father and I sometimes spent time together, he in his armchair in the living room, reading, while I played on the floor with my toy soldiers or sat on the sofa and read or daydreamed. This one particular day I recall looking at him—his big, strong face, big nose, his red-grey moustache and clean-trimmed brown-silver hair, his clear brown eyes and strong jaw, his manly smell of whiskey and tobacco and whiskers. I watched him take a pack of Camels from his pocket and tap one out, strike a match and light it, one eye squinted against the smoke, and I felt a radiance in my heart gazing at this man who knelt by his bed most nights to pray and rose every morning to put on his suit and tie and go out into the world and do what men do so that their families can live. And he was even more than that, it seemed to me then, that morning, as I watched him from the corner of my eye, because in addition to just doing the job he had—which was an important one, he was a leader in a big organization where people called him "Mr. Kennedy," he was a vice president, respected—and in addition to that he wrote po-

ems, too, and his picture was sometimes in the newspapers, when he got another promotion or chaired some committee of the Red Cross or Heart Foundation. And I looked at this man this one particular day, my hero, and my heart opened with love, and I wanted to tell him what I felt for him, and the words that came into my mouth were, "Dad, when I grow up, if I am just half the man that you are, I will be satisfied."

I was maybe ten, which meant that he was forty-eight and only had ten years left to live—only the length of time I had lived to that point. But it must have been a good period for him—or the end of a good period—because as I recall he was sober, the faded nightmare of the DTs he had been through two years before seemed more like a dream left behind on the misty shore of the past, a nightmare. And I was full of admiration for him, my father, my Dad, who went out into the world and did things and was not afraid.

He heard my words and looked up from his book and one nostril puckered as though he had smelled something bad, and he muttered, "Sure. Butter up the old man." He put down his book and stubbed out his cigarette and walked out of the room, and I heard him out in the pantry, taking down a bottle from the top shelf, getting a glass out of the cupboard, heard the cap being screwed off, the chuckle of liquid into the glass.

Stunned, feeling unworthy to be the boy of this good man, I searched in my heart to try to see if he had seen something I was not aware of, some insincerity. Was I just trying to flatter him? No, I meant it. Why then? I wondered. Why did he say that?

It would take decades for me to understand what he was expressing to me with that reaction: His own sense of unworthiness. He could not accept my love and admiration because he did not love or admire himself, and ultimately, that must have been at the heart of what made him give up, what killed him. His own hatred of himself—for whatever reasons.

Illinois—Morning again, pack up the pup tent, roll the sleeping bags, on the bike for another day like so many days before: hour after hour of wheat fields. And then we are out of Indiana, too, entering Illinois, and perhaps my memory is tainted but all I can remember seeing there, throughout all those days, is wheat fields.

On the outskirts of Peoria on Tuesday, September 12th, we pull into a diner for breakfast. By my calculation and to the best of my memory, we have been on the road for twenty -three days, have covered 1,250 miles—approximately a third of the way to San Francisco. I've had it. And I have decided this is the day to bail out, jump ship, quit. We order eggs and mashed potatoes. An enormous, big-bellied cook carrying an enormous pot of mashed potatoes comes out from behind the counter to look through the front window at our bikes, locked against a pole outside.

"Whachoo boys up to?" he asks.

Nick says, "We're biking across the country."

"Across the country? Across this whole country of the United States? Well, gimme them plates." He begins to dol-

lop on mashed potatoes until our plates are huge snowy mounds, and he says, "Har har, feeds ya like Ah feeds mahself!"

I have twenty dollars left from the hundred-fifty I started with. I could wire my mother to send some of my savings, but that is not the point. I've had it. I am bailing out, and this is the day. I tell Nick. "I can't take any more wheat fields. I'm done."

"Tommie," he says, his eyes truly sad. "No. Don't quit. Let's push on."

Nick is such a capable guy. He can do so many things, but there is one thing I can do that he can't: Quit. My father taught me.

I cycle into Peoria that afternoon, find a bike shop and invite an offer. I get twenty bucks and consider myself lucky. Back on the highway, alone in the sunlight, the intensity of my relief is palpable. I am free! For the first time in weeks, I feel light-footed. On my own. Yet I remember the sadness in Nick's eyes, remember the friend who turned his back and muttered, "No guts," and I feel weak. I don't remember feeling weak when I was a boy, and I wonder why I feel that way now, standing on the highway, at last free of the trip, waiting for someone to pick me up.

I reach San Francisco, by thumb, two days later. Haight-Ashbury is a disappointment. Everyone looks dirty and drugged out, sitting on the sidewalk against the building

walls, on curbstones, blank-eyed. It is dark and—perhaps a fluke of memory—quiet. Quiet and still as an old photograph. A skinny guy with no front teeth and filthy bare feet asks if I want to buy some meth.

Next morning, I return by bus to New York.

Nick continues down through Mexico and Central America and has a great adventure for himself. He is no doubt better off without me holding him back from pushing on. We meet in New York a month later, in Queens, at the Friendly, to exchange laughing memories of our time together on the road. He doesn't mention the day I quit, but it is there inside me like a wound.

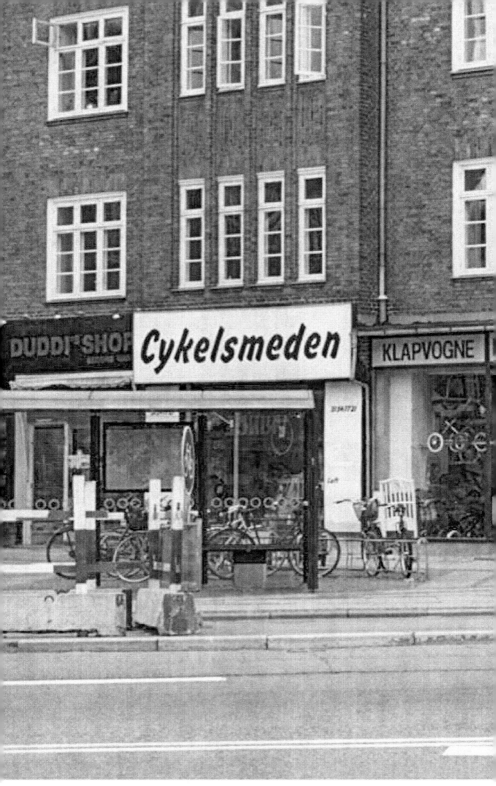

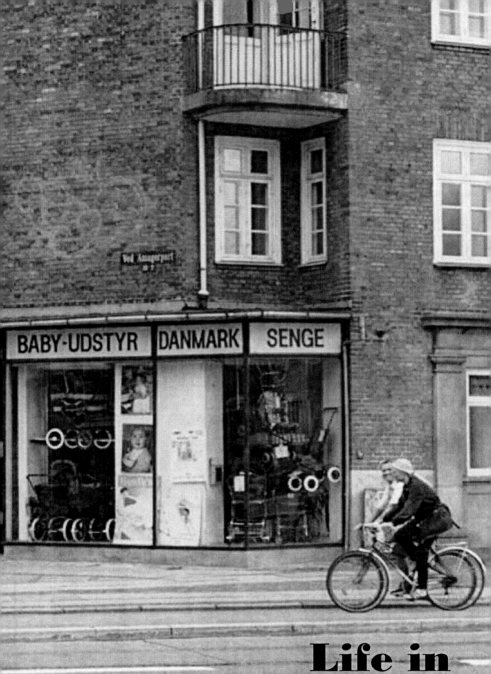

BABY-UDSTYR DANMARK SENGE

Life in
Another Language

GARRISON KEILLOR, who spent a lot of time in Denmark, once said, "No Dane would look you in the eye and say, 'This is a great country.' You are supposed to figure that out for yourself." I think it *is* a great country. And that's why I'm still here, some half a lifetime after migrating to Europe from my home in the United States. I've lived in France and travelled frequently throughout much of Europe and elsewhere, but my home-base since the mid-'70s has been Denmark, even if I am still an American citizen, still vote and file taxes in the US—as well as here.

The expatriate life, for me, has been a good one, although it does complicate one's identity. There is no doubt that living in another country, more important in another language, changes your view of things. I know that I will never become completely Danish, yet somehow I also know that I am not quite completely American anymore either. And just as I could never find it in my heart to surrender my American citizenship, I don't think I could bear to leave Copenhagen for more than the few visits I make to the States each year.

As a writer I worked for years in the United States and never published a thing. Not until I had been living in Denmark for a while did I begin to write things that interested American publishers. And I think this was at least partly thanks to the opportunity of viewing my native culture

through the lens of the new one—because I was still writing fiction about American characters in American settings. Only after my fifth book of fiction did I venture to set a novel in Denmark and include Danes among the characters— a challenging and liberating experience, casting Danish sensibilities into English. After that I wrote a novel through the eyes of a Chilean torture survivor and a 40-year-old Danish woman, who is the book's central consciousness—I don't know what that might say about the changes I've been going through. There was not even a single American in that novel.

I was born in New York City, in Queens, but traveled and lived a good deal around the United States before leaving. The atmosphere in which I grew up was one of repression—the '50s and early '60s, a time when apartheid was official policy in some states, unofficial in others, a time of fear—fear of communism, of nuclear invasion, racial integration, sexual liberty, even of language.

Books were routinely banned. The novels of Henry Miller were contraband, as was D. H. Lawrence's *Lady Chatterley's Lover.* Even if Joyce's *Ulysses*—thanks to Bennet Cerf and a US District Judge named Woolsey—had been legal since 1933, no American publisher was willing to take a chance on J. P. Donleavy's wonderfully funny *The Ginger Man*, inspired by, though far milder than, Joyce's masterwork. Aristotle once advised, "The word dog does not bite," but in the America of my youth the word "fuck" could land you in jail—as people like Lenny Bruce and Lenore Kandel in San

Francisco who published a poem entitled "To Fuck with Love" would learn, even if it and other assorted illegal words were in daily use in the popular vocabulary. In Berkeley, in 1964, there was even a movement whose adherents wore signs on their chests proclaiming, "Fuck, Verb," in protest against this unconstitutional prohibition of free speech: *Congress shall make no law...abridging the freedom of speech.*

As the 1960s progressed, many gains were made against such narrow-minded fear of language, free expression of thought, the human body, and politics left of Barry Goldwater. Films like *Dr. Strangelove* and books like *Candy* (originally banned even in France) won the war with laughter. Legislators struggled with definitions of pornography— how to ensure freedom of speech without opening the gate to pornography? Eventually, the impossibility of doing so was recognized. Freedom of expression is freedom of expression. For a time it seemed as though the concept of liberty was breaking through the shell of repressive fear in a society that insisted it practiced "liberty and justice for all"—though liberty and justice were reserved primarily for certain classes of the so-called "classless" American society.

And in some ways freedom of expression *has* triumphed, although speech-control and mind-control take many forms. As noted in a recent *New Yorker* essay by Adam Gopnik, "After the Kennedy assassination the great divide began in which America turned to the right politically while becoming increasingly liberated in its personal manner. By the time

Ronald Reagan was President, you could say 'cocksucker' in any comedy club in Philadelphia..." Striking that this observation should appear in the pages of a magazine that a mere 20 years ago was adamantly committed to keeping any such word from its pages. Today, a rapper is free to spout the word fuck at the speed of frustration, while book and curricula content is controlled by school boards and funding agencies, and professors and school teachers may face serious consequences for certain utterances, for teaching certain books, for risking the wrath of harassment charges (over something as innocent as hanging the painting of a nude on your office wall).

But it was not only such issues that inspired my migration. In the early 1970s, the so-called summer of love had long since gone sour, replaced by violence, drugs, guns, racial and political animosity. I had a girlfriend on East 2nd Street between Avenues B and C—Alphabet City—and because she had a dripping faucet, one of her neighbors emptied a rifle through her door one day. Fortunately, she was not hit, but I think seeing those bullet holes in the door, combined with my own couple of experiences of people shoving guns into my face, ignited my wish to try life in Europe—a wish, admittedly, that had long been fueled by my reading: Dostoevski, Camus, Huxley, Balzac, Flaubert, Gide, Orwell, Grass, Mann, Mansfield, Hemingway, et al.—and most notably James Joyce with his Dedalus proclamation in *A Portrait of the Artist as a Young Man*: "I will not serve that in which I

no longer believe, whether it call itself my home, my father-
land, or my church; and I will try to express myself in some
mode of life or art as freely as I can and as wholly as I can,
using for my defense the only arms I allow myself to use—
silence, exile, and cunning."

Following the Alphabet City shooting, my girlfriend
grew troubled. What had attracted me to her was the simple
clarity of her nature, her slender, freckled confidence and
level-headed healthiness. After the bullets, she developed the
conviction that I was bribing the mailman to spy on her and
that she was in telepathic contact with Yuri Geller. Today, in
Denmark, it is standard practice to offer psychological crisis
help after such an experience. I don't know if any of the
States do that now, but there was no such offer back then in
laissez-faire New York.

Right about then I was working for an international or-
ganization which sent me to Copenhagen to attend a confer-
ence. My first evening here, out alone sampling the good
Danish beer, I lost my way amidst the dark, narrow, winding
streets, my footsteps echoing on the cobblestones, and I felt
quite relaxed. I thought, Here is where I want to live. It was
such a contrast to the night, after an Elton John concert in
Central Park, when I lost my way somewhere toward the
North Meadow and did not feel at all relaxed.

But it was not only the peace, not only the Danish beer,
virtually everything about Copenhagen attracted me: the
elegant old buildings, the thousand-year history, the people,

their calmly friendly manner, the Danish smile, and the Danish distance as well—I liked the fact that Danes grant a perimeter of solitude. This is a contrast to the open-hearted jovial welcome that Americans tend to extend to newcomers.

Another thing that won me was the Danish light—the light nights of summer and the big sky, especially compared to New York City where the sky is mostly just another tall, thin building amongst tall thin buildings, but also the profound darkness of winter with its quiet, moody beauty and the many candles that Danes light against that darkness. At the height of summer, the day starts around three a.m. and ends around ten at night; in deep winter, the day starts near ten a.m. and ends around four in the afternoon.

Perhaps those short winter days are particularly attractive to a writer. They give a quiet and a peace that is conducive to meditation. But best are the summer evenings, yellow skies that take long, slow hours to fade into a pale, ever-darkening blue with the streets going dark more quickly than the sky. It is like the Magritte painting, "Empire of Light"— a dark street scene beneath a daylight-bright sky, one of his many paradoxical pictures (is it night or day?); but here in the north that paradox is plain reality.

The impact of the changing seasonal light, in fact, inspired the four-novel progress I published under the collective title of the *Copenhagen Quartet* (2002-2005), each new

novel "embedded," if you will, in one of the four Danish seasons.

And I recall walking one summer afternoon at the end of the '70s along the bank of one of the street lakes on the north side of Copenhagen and seeing there, lying alone and unafraid on the sloping grass, a purely naked young woman sunning herself, eyes closed in the warm pleasure of the light, and that remains for me in memory a symbol of the northern Europe which drew me to it.

That might seem a frivolous or romantic vision, but for me it was neither. In the US of my youth, public nudity was illegal and, to the best of my knowledge, still is most places. A woman breast-feeding a child in public is a matter of controversy. Yet what could be more lovely? How odd that human beings will pay large sums of money to watch two men punch one another bloody yet are disturbed by a woman breastfeeding a baby. One of the oldest public monuments in Copenhagen, the four-century old Charity Fountain, depicts Charity sculpted as the Virgo Lactans, translated literally from the Danish name as "The Nipple-Giving Virgin"—the fountain's water sprays from the Virgin's breasts.

The easy acceptance of the body and human sexuality in Denmark, in most of Europe, seems to me also an aspect of the mind-set upon which Danish society is built. Most Danes would smile incredulously to learn that not until 2003 did the American Supreme Court declare unconstitutional the laws in 13 States prohibiting consensual homosexuality (and/or

assorted acts of heterosexual "sodomy"); here same-sex marriages and consensual sexual behavior have been a human right for years.

This sense of openness, fairness, mutual personal respect has produced a social system by which, for example, comprehensive medical care is provided to all in an equal manner. Education, through university, including medical school, is provided equitably and free of charge. In fact, university students here receive a small salary from the state, for to study is considered an effort on behalf of the public good. By contrast, on the day of writing this, I saw an article in *The New York Times* subtitled, "Millions of college students will have to shoulder more of the costs of their education under federal rules imposed last month."

Full dental care for children is provided free of charge here until the sixteenth year, by which time most Danes have a good set of teeth with which to start their adult lives. By the time I was 16, my mouth looked like a silver mine of fillings; my two kids—born and raised here—at that age had never had a single cavity.

There are also humane laws governing employment conditions, working hours, and firing procedures—you can't just kick someone out here—and well-organized unions for everybody, with tax-deductible union dues.

The death penalty is unconstitutional, as it is in all Member States of the European Union. How sad to think that for one brief shining moment in the US there was a moratorium

on executions—until a psychopathic killer in Utah challenged the system and demanded his right to face the firing squad, thus unleashing a system over the past decades by which many hundreds of people have been exterminated by gas, electricity, bullets, noose, and lethal injection—some percentage of them, as indicated by DNA technology, innocent. Equally distressing to consider that the current President of the United States was governor of the state which has the highest execution record and according to at least one report even privately mocked a woman on death row who begged him for mercy. His brother, too, governs a state that pointedly made no apology for the faulty electric chair that burned a condemned man to death. *That'll show 'em what they get!*

It strikes me as less than fortunate that The Land of the Free has an inordinate proportion of its citizens in prison for nonviolent crimes. If you take a ride on a Greyhound bus most places in the United States you will have an opportunity to meet any number of people on their way home from prison. Early in 2003, as reported elsewhere in this book, riding the dog from Greenville to Beaufort, South Carolina, one of my fellow passengers was a 23-year-old black man carrying his worldly possessions in a shoe box and brown paper bag, on his way home from prison where he had been since he was sixteen. For what? I didn't ask him, but I could guess: drug abuse. He was a quiet, non-aggressive, self-effacing young man, frightened at the prospect of changing buses on

the way, afraid he could not find the connection. I helped him, and in Beaufort his mother and sister were waiting for him; before hurrying into their arms, he turned to me, pressed his palms together, bowed his head and said, "Thank you, sir. Thank you for your kindness."

I literally shudder to think of a teenaged boy being locked away in prison for years—the kind of prison we have come to witness on Discovery channel or in Tom Wolfe's *A Man in Full* or in Pete Earley's study of life inside Leavenworth Prison where every job applicant—including clerical workers, prison counselors, even the prison psychologist—is asked whether he would shoot an inmate trying to climb over the wall; those who say no are not hired. I have had the opportunity to visit two prisons in Denmark on a study tour—a so-called open prison and a maximum security facility. Even the maximum security prison at Albertslund treated its inmates with respect, aiming to offer them as normal a life as possible and help them back to society. The guards don't even carry guns or other weapons. I am not suggesting that time in a Danish prison is easy. However, one of the inmates there told me he had seen a program on Discovery about an American prison. He said that one would not lock dogs up under such conditions. Then he asked, "What do you think a dog who has been locked up that way would do when he is let loose again? Don't you think he would attack?"

*

There is so much to admire about America, a land of vast natural beauty and bounty, of friendly generous hospitable inventive industrious people. The record of its generosity and accomplishments speaks for itself. It put a man on the moon, helped rebuild Europe and Japan after World War II. It has the world's best paper towels, toilet paper, doorknobs, band-aids, plumbing, cola, potato chips, pretzels, refrigerator baggies, staplers, supermarkets, aluminum foil and plastic wrap. But it also, for example, breeds global plagues such as McDonalds, Burger King, Kentucky Fried Chicken, 7-Eleven, Pizza Hut—on the Champs-Élysées in Paris is a McDonalds. In Moscow, Beijing, London, Dublin, everywhere, you find them. The prime corners of Copenhagen at the City Hall Square are blemished with the gaudy facades of a 7-Eleven, Burger King, and KFC. At one corner of the ancient and beautiful Amager Torv, where Hans Christian Andersen and Søren Kierkegaard once took their coffee, is a McDonalds. At one corner of Copenhagen's excellent east-side Triangle square, in a building where one of the Czars of Russia once slept, is a 7-Eleven with another going up not 500 yards away in one direction, a McDonalds and 7-Eleven 500 yards in another. I once recited this Jeremiad to an American poet I met in Geneva, assuming she would be sensitive to my distress, and she exclaimed, "Why, McDonalds are delicious! What right do you have to criticize? You jumped ship!"

Perhaps that also precludes me from lamenting the fact that the US has contributed to the education of torturers to support corrupt regimes, and has instituted torture itself, sanctioned all the way up to the commander-in-chief. The response of Denmark to this ghastly phenomenon—the widespread use of torture—has been to establish a Rehabilitation Center for Torture Victims from around the world, a model for the many such centers which have now been established in numerous other countries. In the post 9/11 world, where new categories of imprisonment are devised to evade even the most minimal humanitarian requisites, concern about the employment of torture is perhaps even less pronounced than before; but research conducted in the Copenhagen Rehabilitation Center has shown that torture is not merely employed to extract information that might prevent future terror or rebellion; it is as often employed to break the spirits and bodies of strong human beings who might pose a threat to the status quo. Just as one might be forgiven for wondering what junk food does to the strong bodies of the poor. (In fairness, I should add that the American Congress not long ago paid public tribute to the Danish physician Inge Genefke, a founder of Copenhagen's first torture rehabilitation clinic, for her continuing international crusade.)

Unfortunately, over the past five years since the American invasion of Iraq (with, alas, the assistance of Denmark), we have seen continuing, alarming evidence of the employment of torture by American authorities. Some argue that

this is the only way to combat terrorism, but Inge Genefke quotes the great French author Albert Camus in responding to such claims: "Torture does not stop terrorists; it creates them."

Other, less dramatic aspects of the Danish society which I admire include the fact that there are no tolls on Danish highways, that there are excellent public transport systems, that the authorities see to it that streets, sidewalks, public buildings are kept in relatively good repair.

Now you may ask, who pays for all this?

The taxpayers. All of them. Even those on the dole—for even if you are on the dole here you pay tax. And the tax rates are formidable. A blanket sales tax of 25% on virtually everything. Income tax rates up to around 60%. And luxury taxes that are hard to believe; it is said that when a Dane buys a car, he buys two cars, one for himself and one for the State. (Personally I turned mine over to my first duchess when we parted and have not owned, needed, or wanted an automobile since, content with my bicycle, the excellent public trains and buses, the taxi system, and a pair of legs by which I enjoy being propelled through the streets of this beautiful city in which I live.)

I admit that the Danish internal revenue service can seem like a legalized terrorist organization. There are also excesses in the administration of the tax system here—both in the taxing and in the doling out. When I received my first paycheck in Denmark, I was shocked at how little was left

after state and county taxes were withheld. Seeing my distress, my father-in-law called me aside. "Look," he said. "Don't focus on what's written on your pay stub. Ask yourself if you have a good life. Do you live well? Eat well? Do your children have a good environment? Does your family have a good life?" And he was right. I had and continue to have a good life here regardless of the discrepancy between my gross and net income.

My two children are currently studying at Copenhagen University. In the United States, if you have two children entering the university, it is time for most people to take out a second mortgage on the house. Here, I've already paid it over the years through my taxes. More importantly, *no one* here is denied a good education because they don't have the money. As Oliver Wendell Holmes put it, "With taxes you build civilization." And as Thomas Friedman put it in *The New York Times*, "Democrats should ask the voters to substitute the word 'services' for 'taxes' every time they hear the President speak."

Now Denmark is, of course, a country of a mere 5.4 million, immensely smaller and immensely easier to administer than the U.S. Life is far from perfect here, but some important values do tend to take the front seat, even if the current minority right-centrist government—which also supported the second American excursion in Iraq in search of those still infamously elusive Weapons of Mass Destruction—is working to curtail those values. Inter alia, the Prime Minister,

pressed by his extreme right minority partner, has emulated George Bush's pressure tactic that resulted in the expulsion of Mary Robinson as UN Human Rights Commissioner for criticizing the US; by manipulating funds, the Danish PM has had some success in bullying Denmark's own human rights commission into "harmonizing" its thinking with the establishment's.

One of the aspects of the Danish society that initially surprised me is the amount of free time one has. When I lived in the U.S. it was standard practice for private employers to provide one week's vacation per year for the first three years of employment, doling out extra weeks over the course of the next 20 years. In Denmark, when I learned I would have six weeks vacation a year right from the start, I was stunned: *Impossible!* I thought. How will we ever get anything done? Which now sounds to me like a slave asking how he'll ever manage without his manacles. In fact, the Danes are an industrious people. They work hard and get the job done with lots of time left over to play—or to follow an avocation. With the job that I left four years ago after a couple of decades to become a full-time writer, I had seven weeks holiday and two weeks personal-development time a year with a two-thousand dollar annual travel budget. I worked a 36-hour week, and like all Danes I had a five-day weekend for Easter, and a number of other three- and four-day weekends as well as three days off for Christmas. This made it possible for me

to manage two careers—a full-time executive job as well as my literary career which by itself would not have provided sufficient income to give my family a good life.

And I do like the way Danes celebrate their holidays—particularly with that most sublime of creations, the traditional Danish lunch, a table laden with anywhere from five or six to 20 or more delicacies: a variety of herrings (marinated, pickled, curried, sherried, fried, smoked), smoked eel, boar paté, fish fillets breaded and fried, raw chopped beef with raw egg yoke and onion, roast pork with crackling, cod roe boiled or smoked, smoked cod livers, the eggs of various fishes, shrimp, liver, heart, meat drippings, fried onions, remoulade sauce, red cabbage, cress, chives, half a dozen excellent breads with butter—actual *butter*, not "spread"—and a variety of cheeses, including if you are lucky one so old it is tinged pink and delicately radiates your gums as you eat it, demanding to be chased with strong beer and a chilled aquavite—also known as "snaps," from the German, to snap it down.

I like the rituals of the lunch, too. The initial formality that slowly gives way with the beer and snaps. The ritual of the skål—raising the glass, looking each person at the table in the eye, saying "*Skål!*", taking a sip, "presenting" the glass again with a slight, formal nod, then proceeding with the herring. Fish must swim, the Danes say. Such rituals are valuable to a society, to a culture.

Some people complain that Danes drink too much, and no doubt some do. The minimum drinking age is *fifteen*! A lawyer-colleague recently told me, "Every time I have a beer I feel like a new man. The trouble is, that new man wants a beer, too."

But in fact, beer and snaps is a ritualistic drink which is part of the traditional social fabric here. At Christmas time, for example, Danes take drink with their meals to celebrate a combination of things—not really so much the Christian feast as the winter solstice, the closeness of family and friends and the belief that the long, dark Danish winter is *not* death, but rather the beginning of the birth of spring. At that very dark time of year—and it *does* get dark; Shakespeare chose his setting for *Hamlet* well—ritual is important: the mellowing of the spirit, the so-called living light of burning candles on the living Christmas tree, the joyous dance around it by all present holding hands in a circle, the calm peaceful stillness in the streets of Christmas Eve in this city of a million souls is awe-inspiring: The city stops. The quiet is sacred. This darkest night of year wraps around you, wherever you are, in the heart of your family, surrounded by friends, even alone, the silence is calming, beautiful in its mystery.

Being a small society with a largely homogeneous population, the Kingdom of Denmark is held together by its language, well-defined customs and manners and a humanistic view of life regardless of who sits at the helm of government.

Naturally, Danes cherish their language and its rich litera-
ture and wealth of psalms (hymns), a national treasure ac-
cessible only to those who know Danish. The language is
nourished by its poets and writers of whom there are many,
though few well known beyond the Danish borders—Hans
Christian Andersen, of course, one of the world's great writ-
ers, erroneously considered an author of children's books.
Andersen wrote poetry, drama, novels, travel books, but as
his friend, H. C. Ørsted, who discovered electromagnetism,
once correctly predicted, "Your novels have made you fa-
mous, but your tales will make you immortal." Søren Kierke-
gaard is another of the great Danish writers, known as the
father of existentialism, the philosophy that became so im-
portant to the battered consciousness of the 20th century.
Karen Blixen, too, also known as Isak Dinesen, though per-
haps better known now as Meryl Streep in *Out of Africa*. A
better Blixen-inspired film is Gabriel Axel's *Babette's Feast*,
which won an Academy Award in 1988, based on her fine
short-story, contrasting the spiritual sensuality of France
with the anti-sensual religion of the black-clad Jutland Chris-
tian sect of the Inner Mission (roughly equivalent to the ex-
treme American Baptist). Another Danish fiction writer—
admired greatly by Joyce, Rilke, and Freud—is J. P.
Jacobsen, and from the novel and film *Smilla's Sense of
Snow*, many will know the contemporary Peter Høeg.

In recent times there has been international recognition
of Danish film (Lars van Trier, Thomas Vinterberg, Gabriel

Axel, Bille August, and others), but most Danish writers remain unknown in the world beyond Scandinavia. And the reason for this could only be that even the most skillful translation might fail to convey the context and special qualities of a language and its literature. (Readers who would like a glimpse of some 25 contemporary Danish poets and prose writers translated into English are referred to the spring 2008 issue of *The Literary Review*, devoted exclusively to "New Danish Writing.")

Perhaps the most essential quality of Danish is the way in which Danish speakers employ irony, understatements so dry that even an outsider who speaks the language might miss them. Irony—and perhaps especially self-irony—is an important component of the Danish language and nature, just as it is important here not to be too enthusiastic. Danes value calm and understatement.

And irony is not to be confused with sarcasm—a mean-spirited cousin of the more playful irony in which one speaks in reversals: "Lovely weather," a Dane might say when it is cold and rainy. Or, "That wasn't the worst dinner I've ever eaten" to mean it was delicious. Or if something is very unclear, a Dane might say, *"Klart nok,"* meaning literally, "Clear enough," although the message is, "Murky."

Recently I heard a Danish fellow describe a pleasant experience by saying, "It was not pure suffering," and once, in a Danish serving house late at night, I heard a Danish fellow try to express his admiration for a woman by saying, "You

are not the ugliest woman I has ever seed." In some parts of the country, in northern Jutland for example, I am told that if a person goes to the doctor and says, "I think I have a kind of uncomfortable feeling in my stomach," he must be rushed to the hospital.

Self-irony is important here just as self-seriousness is bad form. You have to be able to laugh at yourself. If a Dane falls in the street, he or she will likely laugh or smile. But more likely than not, one or several hands will reach to help.

The special character of the language and the near untranslatability of some Danish can be demonstrated by rendering a very literal version of some of the most Danish of things, the songs of the poet Benny Andersen; for example, the refrain of one of the best-loved of them would translate literally: "Life is not the worst thing one has / And soon the coffee is ready." And, "Nina comes naked from the bath / While I eat a cheese sandwich." Of course, in Danish, these lines rhyme, but something simple and sound about the sentiment expresses an essence of the Danish joy of life.

There are other things that sound utterly mad in translation. For example, a not uncommon thing to hear in response to the giving of a gift is, *"Hold da kæft, er du rigtig klog?"* Which literally means something like, "Shut your mouth, are you really stupid?" I guess the spirit of it is, "You must be stupid to give me such a wonderful gift!"

It is also enchanting how direct Danish can be: In English, we have the delicate word "brassiere" whose Danish

equivalent, *"brystholder,"* is literally, "breast holder." The Danes do not believe in calling a spade a shovel. Some words are rather poetic, though: Midwife in Danish is literally "earth mother" (*jordemor*). Nor does Danish tend to prettify itself with Latinate words: A dentist is a "tooth doctor," gingivitis is "tooth meat infection," and a vagina in common Danish parlance is a *tissekone*—literally, a "piss-wife." The "lavatory" or "sanitary arrangements" are the "toilet"—nor do you "go to the bathroom" in Danish; you go "on the toilet." But Danish can also be circumspect. To be in *"vældig godt"* humor (very good humor) or to have "a couple under the vest" is to be pretty drunk.

The Danish language is not one that you would be likely to study without good reason: James Joyce, for example, studied Danish to be able to read Ibsen in original (at that time, Norway was a part of Denmark and Danish its official language). My own Danish is far from perfect. When I was interviewed in the Danish daily, *Politiken*, the otherwise very kind journalist, who generously praised my writing, could not resist poking fun at my accent. One of the banes of my existence as a writer in Denmark is that I have great difficulty getting my mouth around the Danish plural for books—the singular is no problem, but the plural comes out—in English equivalent—something like "boks," and my *Politiken* interviewer could not resist an orthographic spelling when I spoke about my "boks".

Friendly teasing. In fact, in all my time here, people have seldom commented on my accent, other than occasionally to call it "charming" (though of course in the world of Danish irony, one might consider what that means). Perhaps four times in thirty years people have mocked my accent, and only once in a truly nasty manner.

I was interviewed in Danish by two Danish TV channels in connection with the publication of my first Copenhagen novel, in each case a five-minute spot which took many hours to produce since I was interviewed on location against a variety of the city's backgrounds. In both cases, the interviewer at the end of production confided apologetically that the station might decide to use subtitles as they occasionally do when someone with a heavy Danish dialect speaks on the channel. They were afraid the viewers at home might not be able to understand my Danish so, to assist them, the words might appear simultaneously in print beneath the picture. "We do it for Swedes," the journalist said consolingly (Swedish and Danish are very close linguistic cousins). This inspired a series of interesting emotions—that after all these years here, my Danish might seem so utterly foreign to the native-speakers that I might as well be speaking some impenetrable dialect. A thought that can make a person feel lonely, like Tony the fruitman of the literary world. That in the end they chose to let my Danish run raw was a relief— though perhaps akin to passing an important exam by the skin of the teeth.

But it also helped to inform my writing of the novel *Greene's Summer* about Bernardo Greene, a Chilean refugee who in his homeland was tortured because his teaching curriculum included the work of a poet who had been executed for verse deemed revolutionary in championing the poor. Deprived of the daily use of his mother tongue, Bernardo must revert to a choice between broken Danish and broken English. In the language school he attends to learn Danish, he meets other refugees, from Palestine and Israel, who can speak four or five languages, but none with mastery. They have no mother tongue—a prospect which terrifies Nardo for he recognizes—as did Balboa exploring the new world—"*Por no saber paner los nombres, no las expresos*": Because I do not know the names of things, I cannot express them.

Human beings are extremely sensitive to the manner in which their language is spoken. In my old New York neighborhood, I was surrounded by an exciting array of accents—Italian, Greek, Yiddish, Hispanic, Irish, German, not to mention the variety of American patterns. Today Americans seem truly to wish to embrace the multicultural basis of their society; in those days, we were less kind—even to our fellow whitebread citizens. Americans from anywhere outside the New York metropolitan area spoke, we were convinced, "like hicks." Bostonians sounded stupid because they said "ruf" instead of "roof," "ca" instead of "car." Upstate New Yorkers rolled their 'r's—or perhaps it was just that they

pronounced them—and we didn't like that either. And southerners and westerners—*fu-ged-aboud-id*! Of course, I've tried it on my travels in the states, too; I remember a Michigan sergeant in the army who cracked up every time I said "water"—*warda*—and a kid in California, who used to visit me just to hear me say the word "dog." "Ha! *Dawg*!"

When my Danish wife visited New York the first time, the occasional American would guffaw in her face for a mispronounced word amidst her otherwise impeccable English. Once because she had pronounced the word "mayonnaise" as "myonnaise," another time because she pronounced the "y" in "syringe" as a long "i". The latter case involved a relative of mine with a PhD in science who, when she mouthed that long "i", leered at her as though he'd just seen her naked. And it occurred to me how edgily parochial and fear-driven is the compulsion to pronounce words "correctly" and to recoil from or pounce upon those ignorant of the "preferred" sound, who thus exhibit their "otherness"; as though saying "sigh-ringe" instead of "suh-ringe" had stripped away the deceptive garment of my wife's excellent English so my provincial cousin finally clearly saw the nakedly subversive, half-commie Dane she really was.

At Dulles airport last year I chatted with a young woman who asked where my accent was from; I told her New York via Copenhagen and asked about hers. "We don't hay-ave accents whare *Ah* was born 'n' bred," she solemnly informed me.

There is a brilliant scene in the 1980 remake of the film, *The Postman Always Rings Twice* in which Frank Chambers (Jack Nicholson) conforms to his Greek boss's mispronunciation of the word "neon"; the establishment decides how we are to pronounce things, and the establishment is whoever owns the joint and administers the food and money. Hearing someone say *"De Good Nyews Bout Jedus Christ Wa Luke Write"* might be amusing or worse to the provincial ear, but delightful to those who recognize it as the official Gullah Sea Island Creole translation of "The Gospel According to Luke," in which *"Luke tell wa dis Book taak bout."*

Secretly I loved the variety of accents that abounded in my childhood. I loved the way the parents of one of my Puerto Rican friends would add an "e" before any initial "s"—*"The United E-states"*—and sounded an initial "v" as "b" ("Bery good!"). After school for a while I worked for a Greek shoemaker who pronounced "rubber" as "wobba" and "gloves" as "golves"; I lived for the times he would ask me to bring him his "wobba golves." And I admired the manners of the Latins whose *casa* was always your *casa* and were, despite the stereotype of the Latin temper, in fact much slower to anger than my Irish friends, some of whom took any form of address as provocation:

"How ya doin'?"

"The fuck ya mean by that? I don know you."

I read in *The New York Times* not long ago an account by 21-year-old Ozzie Garcia, an ex-gang member in LA, who

asked some guys in the street, "What's crackin'?" whereupon they drew guns and shot him in the neck, breaking his jaw. In a sense, it seems chillingly apt that the bullets broke his jaw, as they were a response to his words. The former House Majority Leader, Tom Delay, attributed the Columbine school shootings to words, too—the teaching of evolutionary theory in the schools. Some seven states, in fact, have succeeded in effectively regulating the teaching of evolutionary theory; yet even if the US has the highest gun casualty rate in the world, little success has been achieved in regulating them. To some, it seems, words are still more dangerous than guns. And maybe they are. But still the word dog does not bite.

Not until I felt comfortable enough with my Danish that I could attend a party without reverting to English did I really begin to get a feeling for the Danish psychology, the Danish use of irony and understatement and the humor, and begin to feel at home here. I have known a couple of expatriates who lived here for years seeming essentially uninterested in Denmark, as though that which is different here is an affront to their own national characteristics, people who did not like where they were and do not like where they are now, clustering together in isolation, cheating themselves of an immersion in the Danish culture and language.

Nor am I talking here on behalf of the current catchphrases, "integration" and "assimilation." Those from other cultures, the Danish jingoist minority insists, must embrace

the Danish values and tongue, must dress and act like Danes, young Muslim women must uncover their heads, etc. And the Danish language must not admit foreign words—which is surely the best way to kill a language, by denying it flexibility. France tried it in an effort to maintain French as the international diplomatic language, and the result is that French has been forced to give ground on every front.

But language cannot successfully be legislated from above; linguistic development is from street to dictionary. Danes, who have no real equivalent for the multi-purpose English word "fuck," have already assimilated it. In Danish, the "curse" words are still literally curse words; the traditional words of "strong" language in Denmark are "Satan" and "hell," although a gaudy array of vulgarities such as "ass banana" and "betoothéd cunt" are also available if needed.

I wish that some of the wonderful phrases in Danish would be adopted by English. Consider a term like *"kærestesorg"*—literally "sweetheart sorrow"—an expression to denote the sadness one feels when a love affair is over or in danger. In fact, "sweetheart sorrow" can be an acceptable excuse for a late school assignment or for missing a day of work. I think that gives an idea of the humanity here.

There is another Danish saying, *"skam ros"*—"shame praise"—to lay it on so thick the praise becomes embarrassing and perhaps ironic. Lest I be accused of shame-praising Denmark, perhaps I should conclude by pointing to what I see as some of the faults of the society and the culture.

Of course, the whole array of western problems is here, increasing crime, soccer hooliganism, shop-lifting, homelessness, even street violence I am sad to say, even guns and knives, and all of the western sorrow of disintegrating family patterns—though I sometimes wonder whether the problem is that the family unit is disintegrating or that it is not disintegrating quickly enough, that the alternative of extended families and networks is not yet sufficiently in place and functional.

One of the most noted foibles of the Danish character is the so-called Law of Jante—defined in a novel by the Danish -Norwegian writer Axel Sandmose. The Law of Jante is a kind of modern ironic re-rendering of the Ten Commandments for a hung-up society; these commandments caution people not to try to be clever and excel lest they be noticed, envied, and thus disliked for—another Danish expression – "carrying your flag so high your feet don't touch the ground."

The first Law of Jante is: "You shall not believe you *are* someone."

"You shall not believe you are more clever than we."

"You shall not believe you are good at anything."

"You shall not believe you can teach us anything new."

But the fact that Danes greatly appreciate the much-quoted Jante Law seems to me equally a sign of their opennness to criticism of their own society. In fact, unlike some other nationalities, Danes are often positively amused

to have foreigners identify some of their foibles, as long as it is not done with malice. Danes generally respond well to stimulus. For example, it is said that when you see a group of Danes standing in a circle, talking in low animated voices, if you move closer to them and listen, you will hear one of them saying, "And then we had...and then we had...and then we had...," giving a blow-by-blow description of a wonderful meal. With a single exception, I've yet to meet a Dane who wasn't delighted with that bit of teasing about the Danish love of good food—in fact, I first heard the story from a Dane.

Sadly, one of the things the Danish society has been having trouble with in recent years is learning to make room for other cultures—something that the United States seems finally to have begun to learn to do, making real efforts in the direction of multiculturality, to eliminate not only open racism but also its more covert forms and the kind of colonial thinking that looks down upon cultures other than the white Christian.

In Denmark today, about five percent of the population consists of immigrants and refugees—about 250,000 out of some 5.4 million—though a large percentage of them is of European cultural background—and there have been cultural misunderstandings in recent years of a sort that might seem foreign to some Americans today. Emotional flare-ups over things as simple as a Muslim girl wearing a kerchief on her hair in school or a cashier wearing one on a check-out line

in the supermarket and misguided attempts to make rules forbidding it. From the other side, we have seen the unfortunate misunderstandings over the so-called Mohammed cartoons in which western reverence for freedom of expression clashed with Islamic reverence for the sanctity of their prophet—once again a confusion between word and object, symbol and reality. The word dog truly does not bite. And this is not a pipe. And that is not Mohammed with a bomb in his turban – it is a cartoon.

As I look back on my early youth in New York, it seems to me that an enormous proportion of us—perhaps like most Germans under the Third Reich—managed to be sufficiently ill-informed to avoid considering that America was a racist nation. Racist practices finally became illegal—that is, the stated principles of the Founding Fathers finally began to be applied—the apartheid of the American south that was practised right up to the '50s and '60s was eliminated and things got better, though of course many of the residual problems are far from solved. Just consider the disproportionate number of African-Americans in the terribly overcrowded American prison system and their disproportionate poverty.

Denmark, however, comes from a situation where racism and bigotry were virtually unknown—no doubt precisely because the society was so homogeneous. Of course there was the whole array of ugly bigot patter, racial and national slurs—non-whites were *"fejlfarvet"* (an alliterative phrase meaning literally "wrong-colored"), southern Europeans

were "spaghettis," Pakistanis and Turks lumped under the slur, "*Perker*." But it came as a shock recently to find that an extreme right-wing party could garner a thirteen percent chunk of the electorate in Denmark mostly on the background of xenophobic attitudes and blatant anti-Islamic assertions, something George Bush took pains to avoid even after 9/11.

An amusing cartoon in the Danish newspaper *Politiken* focuses on the fact that this same party sponsored a penguin in the public zoo. In the cartoon—a daily strip (alas no longer being published) by the political satirist, Jakob Martin Strid—the penguin in question protests, refusing to be sponsored by racists; advised that he is liable to legal action for calling the party racist, he responds, "I'm an animal! I don't have to obey laws! They're *racists*! *Racists*! *Racists*!" (I should add that, as we go to press, the Danish Supreme Court decided in favor of the person being sued for having referred to the head of the party in question as racist.)

That party—the Danish Folk Party—has also begun to force through some quite ridiculous and alarming legislation—intricate regulations, for example, regarding the national background of a foreigner that a Danish citizen may marry and has succeeded in drastically reducing the immigration rate and holding refugee applicants in crowded camps—apparently unalarmed by the decreasing Danish birth rate and lack of Danish expertise in certain fields, not

to mention the assault on the country's traditional humanism.

More or less the only time I get to meet immigrants with a non-European background is when I take a taxi or buy something from one of the small local convenience shops, known here as "kiosks." This would seem to indicate that applications for employment from people with non-Danish sounding names are not regularly included on the short-lists. Statistics seem to confirm this, too—I understand that 65 % of immigrants in Denmark are unemployed. Some claim that the lowest-paying jobs are no more lucrative, after taxes, than welfare payments, and that this is a disincentive for those on the lowest rung of the society here to take a job. I don't doubt that there are some working the relatively generous welfare system—there are more than a few Danes doing that, too—collect unemployment or a social allowance and work off the books, even buy a dog because there is an extra allowance for pets, too. But I find it difficult to believe that this can account for the entire immigrant unemployment statistic, or even a major part of it.

In my work, I do a great deal of travelling and usually get out to the aiport by taxi. More often than not the driver is a non-European or second-generation immigrant (a so-called "New Dane," itself a questionable expression) from Turkey, Pakistan, Palestine, Morocco, Bangladesh... Because of my accent they often speak frankly with me. I recall one young man in his mid-20s who was, in fact, a Danish citi

zen but who despised Danes. He was so angry he made me angry, but I tried to use the 20-minute drive to the airport playing good-will ambassador, highlighting positive aspects of the Danish culture; I don't know if it helped, but he seemed less angry when we parted—even got out of the cab to shake my hand and wish me a good journey.

Another young man—also a Danish citizen with a dark complexion—asked where I came from. I told him and asked his nationality. In perfect Danish, he said, "Danish. I was born here, but I'm not treated like a Dane." He said it quietly, a mannerly, well-spoken young man, a medical student who drove a cab on the side. He was about my own son's age, and it saddened me to think that he was not being treated well, that people were prejudiced against his appearance and his Turkish family name.

I am not saying there is not another side to this, too— where Danish liberality is sometimes interpreted, and abused, as weakness or the freedom of Danish women as immorality. All based on lack of communication and misunderstanding.

Not too long ago I took a taxi from the hospital where my wife had just been admitted for an operation, and my Pakistani cab driver asked if I had been visiting a friend there. "My wife," I told him. "She's going to have a tumor removed. We don't know what it is." In heavily accented Danish, the driver said, "I am very sorry to hear that. I will

pray for you both. We are all in God's hands. I will pray for you."

How unusual it seemed to have a total stranger express such sympathetic concern. I was moved, and it occurred to me how well it spoke of his culture, and how many things might be gained by an opening of the Danish way of life to include some of the ways of other cultures, too—not merely to integrate or assimilate the others and encourage them to embrace Danish values of democracy and humanism. That, too, but also to work for an atmosphere that would allow the different cultures here to exist together and share of each other's experiences, wisdom and manners.

I'm an optimist. I continue to hope for the best. I can remember a time when I was surrounded by terrible bigotry and racial hatred in New York—when the word "nigger" was hardly recognized for the obscenity it is. I still remember forty years ago, when I was 18, a woman I worked with in a Manhattan office sneering at a rhythm and blues song on the radio. "Some nigger is driving around in a cadillac with the money they make off that." It struck me as such a hopelessly hateful statement I thought our world would never get beyond it. Yet today, African-American music is amongst the most central of musical influences, not only in the United States but around the world. Interest in African-American studies in American universities has soared, museums on the era and effects of American slavery and apartheid are now finally earning the support and attention of the American

society at large, and African Americans are increasingly being voted into public office. We may even soon have an African-American president. Even the fact that this possibility is very real underscores the tremendous progress that has been made in the United States—even at a time when its current president seems to have done his utmost to destroy the country and squander its wealth on a colonial war.

The movement toward multiculturalism and postcolonial thinking has, I believe, brought us a long way in a relatively short time—even if it took centuries to get started and even if we are torn between true multi-cultural post-colonial spirit and the primitive urge to violently fashion a world in the image of our own democracy.

Still, it is beautiful to see that at least in some ways tolerance is flowering in contemporary times—the retreat of sexism, the continuing liberation of women from a situation that was, even in my own lifetime, very nearly servitude, the continuing disappearance of homophobia, the fight for economic democracy.

Denmark—like the other Nordic countries and many of the countries of Northern Europe—has been well advanced in these struggles, and I believe that the essential humanism of the Danish people will continue to prevail over the primitive forces attempting to wrest control of this society now.

This is still a country in which health care is provided via the public budget for everyone. Where education is available to all. And where if you are broke, the society will give you a

hand. These are three basic things which seem to me requisites to a true civilization.

Let us commend them to all countries.

ABOUT THE AUTHOR

THOMAS E. KENNEDY's books include eight novels, three short story collections, four essay collections, and several volumes of literary criticism and anthologies. His *Copenhagen Quartet*, four independent novels about the seasons and souls of Copenhagen—*Kerrigan's Copenhagen, A Love Story* (2002), *Bluett's Blue Hours* (2003), *Greene's Summer* (2004), and *Danish Fall* (2005)—was the subject of a DVD documentary film produced in 2004 by Harper College. Other recent books include *Realism & Other Illusions: Essays on the Craft of Fiction* (2002), *The Literary Explorer* (2005) and *Writers on the Job* (2008), the latter two with Walter Cummins, as well as the novel *A Passion in the Desert* (2007) and story collection *Cast Upon the Day* (2007).

Kennedy lives in Denmark and serves as Advisory Editor of *The Literary Review,* and a Senior Editor of the annual *Best New Writing/The Eric Hoffer Awards* as well as Contributing Editor for the Pushcart Prize. He writes the weekly blog *A Shout from Copenhagen,* which appears on the websites *Absinthe: New European Writing,* Google Blogspot, and MySpace as well as co-writing with Walter Cummins two columns on www.WebDelSol.com.

Kennedy has been a faculty member at the Vermont College MFA Program, the Emerson College/Ploughshares International Writing Seminar, the Geneva Writers Conference, and since 2002 the low residency MFA Program at Fairleigh Dickinson University, where he teaches fiction and creative nonfiction. His work has won many awards including the O. Henry and Pushcart Prizes, and his craftwriting has been included in *Best Writing on Writing.* In 2008, Kennedy won a National Magazine Award in the essay category.

For more information, please visit:
www.ThomasEKennedy.com.

Printed in the United States
124297LV00001B/62/P

9 780981 780214